CREATIVE BRITAIN

In film, theatre, music, fashion, design, television and the visual arts, Britain is setting new standards of excellence and innovation. In a series of speeches and specially written chapters covering these and other areas in which the upsurge of British creativity is now evident, Secretary of State Chris Smith emphasizes the common themes that government policies must address: access for the many and not the few; the vital role of creative culture in education throughout life; the links with social regeneration; the enabling of the creative imagination that shapes our sense of identity; and the enormous economic importance of the creative industries, which are worth over £50 billion a year.

The arts can no longer be seen as a luxury item, a dispensable extra on the political agenda. By spelling out their benefits to both the social and the economic health of the nation, *Creative Britain* demonstrates that the nurturing and celebration of creative talent are at the very heart of the regeneration of Britain.

Front of jacket painting: Damien Hirst, *beautiful, all round, lovely day, big toys for big kids, Frank and Lorna, when we are no longer children*, 1998, gloss household paint on canvas, 6ft diameter. Back of jacket painting: Damien Hirst, *beautiful snail crunching under the boot painting*, 1996, gloss household paint on canvas, 7ft. diameter. Photos © Stephen White.

Creative Britain

THE RT HON CHRIS SMITH, MP

Secretary of State for Culture, Media and Sport

faber and faber

This book is dedicated to Dorian Jabri.

First published in 1998
by Faber and Faber Limited
3 Queen Square, London WC1N 3AU

Photoset by Parker Typesetting Service, Leicester
Printed in England by Clays Ltd, Bungay, Suffolk

Quotations from *Murder in the Cathedral* and from
'Little Gidding' by T. S. Eliot, and from *Autumn Journal*
by Louis MacNeice, are reprinted here by permission of
Faber and Faber Ltd.

A CIP record for this book
is available from the British Library
ISBN 0-571-19665-9

10 9 8 7 6 5 4 3 2 1

Contents

In writing the speeches and chapters of this book, I have been greatly assisted by a number of members of staff of the Department of Culture, Media and Sport, and by my special advisers John Newbigin and Julian Eccles. I am very grateful to them. Responsibility for the book's contents rests, of course, entirely with me.

C. S.

Introduction

I must Create a System or be enslav'd by another Man's.
I will not Reason & Compare: my business is to Create.

William Blake, *Jerusalem*, chapter 1, plate 10, lines 20–21

This book is about creativity. It is about the cultural ferment and imaginative heights to which creativity leads, the enormous impact that both creativity and culture have on society and the growing importance to the modern economy of Britain of all those activities and industries that spring from the creative impulse. And it is about the implications of all these things for the development of public policy, and the work of government.

Almost by definition, the creative spirit cannot be pinned down into bureaucratic formats. Creativity, after all, is about adding the deepest value to human life. What, then, can government – with all its legislative and administrative paraphernalia – possibly have to do with this free and soaring aspect of human experience? Is it not the case that government bureaucratizes everything it touches? Does not governmental intervention inevitably diminish the work of the free creator? I would argue, with passion, that it does not. Government cannot itself forge the creative impulse. What it can do is try to nurture it, encourage it, aid its expression, help it achieve maximum impact, and assist society at large in the understanding and appreciation of what is created. These are all things that a government not only can do but must do. The crucial question is how that is best done. In the months since the momentous general election of 1 May 1997, I have tried to set out some thoughts – not perfectly formed, but reaching after truth – in an attempt to answer that question. This book encapsulates that process.

It tries to recognize the things that a government must do to help, and also at the same time the limits to action. Government cannot do everything. There will never be an open governmental chequebook, nor should there be. (There will of course be heated argument about its adequacy.) But how best and most effectively governmental assistance can be provided, how things can be organized, how the best value can be achieved: these are among the issues to be properly considered.

In a way, as well, this is a book about bringing democracy to culture. When we changed the name of the old Department of National Heritage, it was not because heritage is unimportant (it is actually exceptionally important, as a later chapter identifies), but because we wanted something more forward-looking, a name that captured more accurately the new spirit of modern Britain, that signalled the involvement of all. We wanted a name that, for the first time ever in a British administration, was not afraid to use the title of 'culture': something the rest of the world had woken up to decades ago. And a name that helped to take us away from the notion that this is simply the 'Ministry of Fun' to an understanding of the scale of the serious economic value of the work sponsored by the Department.

In changing the name, we also set out four key themes for the work of the Department, and they stand as a useful guide to the nurturing of creative activity and enjoyment that I regard as the proper business of government. The key themes are *access*, *excellence*, *education* and *economic value*. Access, in ensuring that the greatest number of people have the opportunity to experience work of quality. Excellence, in ensuring that governmental support is used to underpin the best, and the most innovative, and the things that would not otherwise find a voice. Education, in ensuring that creativity is not extinguished by the formal education system and beyond. And economic value, in ensuring that the full economic and employment impact of the whole range of creative industries is acknowledged and assisted by government. All of these themes are

interlinked around the focal point of the individual citizen, no matter how high or low their station, having the chance to share cultural experience of the best, either as creator or as participant. This is a profoundly democratic agenda, seeing cultural access as one of the egalitarian building blocks of society. Recognizing the value and sharing the experience: these are the radical things a government can do to help.

Let us not be sidetracked, either, by arguments about whether it is 'high culture' or 'low culture' that is important here. These are misleading distinctions at the best of times. George Benjamin and Noel Gallagher are both musicians of the first rank. One might fit readily into a 'high' classification; the other would probably defy any sort of categorization. I do not believe that matters. There is good and bad in both 'high' and 'low'. Some work is more immediately approachable than other work: that does not make it in any way inherently inferior. Some work appeals to vast numbers, other work to tiny niche groups. So what? What matters is not the imposition of an inappropriate category, but the quality of the work and its ability to transcend geography and class and time. A cultural democracy – a cultured democracy – will want to embrace the best of everything, no matter what labels others may put upon it.

In a later chapter, I mention one particular example which serves to emphasize the point. On a rough, tough estate in South Bristol, the teenage boys have been gradually introduced over the last four years to the magical world of ballet and dance. In pursuing this most improbable-sounding conjunction, they have had visiting performances on the estate; they have attended performances and workshops in Cardiff and London; they have learned the hard physical work of dance for themselves; they have been entranced by what they have seen and learned and experienced. What price there, any distinctions between 'high' and 'low'? *That* is where culture and democracy come together with real benefit.

One of the criticisms that has recently been thrown – thoroughly unjustly – at our new Government is the charge

that we are somehow only interested in the 'popular' in the arts, and not in serious and high culture. Why, they say, is the Prime Minister seen sharing a glass of wine with Noel Gallagher at 10 Downing Street? Why is there talk of 'Cool Britannia' and the impression given that anything modern is good and anything traditional bad? Why is attention always concentrated on movies and pop music and never on the rest of culture? Have we not failed to notice that culture is something rather different from entertainment? This argument is complete nonsense. Leave on one side for a moment the fact that such distinctions between the serious and the popular are tendentious at the best of times – as the Bristol experience demonstrates. But the simple truth is that the charge is not correct. The Prime Minister did indeed invite Oasis to No. 10, but a few days later was at the Cottesloe Theatre being deeply moved by Richard Eyre's production of *King Lear*. The deepest cultural experiences will frequently come, for all of us, from the heights of fine opera or the sweeping sounds of a classical orchestra or the emotional torment of high drama. But we shouldn't ignore the rest of cultural activity at the same time.

Yes, we do recognize the difference between culture and the 'simply entertaining'. But we recognize at the same time – as some of our critics fail to do – that culture can embrace a broad sweep of fine and high-quality activity, of all kinds. It does not need to be highbrow to qualify as 'culture'. It does not need to be élitist. It can appeal to broad masses of people and still have crossed over that threshold from entertainment to cultural excellence. Opening up the cultural life of our country to the widest possible number of people does not, ever, inevitably mean cheapening the experience. Access and excellence go hand in hand, and the evidence is there – from Opera North to the Reithian BBC – to demonstrate how it can be done. And in identifying some of the exciting new modernity that is sometimes inappropriately labelled as 'Cool Britannia' as being worthy of note and of governmental interest, this does not in any sense imply that we are throwing out the traditional or the

historic or the inherited treasures of the artistic repertoire. Just as access and excellence sit together, so too do tradition and innovation. Just because you embrace one does not mean you ditch the other. Such simplistic notions really do not apply to the real world.

Heralding the best of the new, and celebrating the creativity that gives rise to it, means building on the achievements of the past, not ignoring them or denigrating them. Some commentators cannot comprehend that it is perfectly possible to bring the old and new together – but this is possible, and the best assessment of our nation's future will do so.

There is in fact a similarly unhelpful argument that tries to make the opposite case, and which has been mounted by some – particularly in the popular music industry – who, I fear, have misunderstood our interest and our participation in their cause. We had thought the new Government was on our side, they say. It seemed interested in pop and rock culture in a serious way, but some of the things it is now doing are letting us down. It appeared to climb on the 'Cool Britannia' bandwagon and talk up its interest in the world of popular music, but it is now not doing enough for the needs of young musicians. This argument is also untrue, and ignores everything we *are* doing. Our interest in the world of popular music has not been cosmetic or an exercise in bandwagon-spotting; it is a serious attempt to do what government legitimately can do in order to support a major economic force. In a later chapter I spell out how important the development of intellectual property protection internationally is to the success of popular music and musicians; how piracy can be tackled; and how the development of musical talent amongst young people can be assisted. These are all things that a government can and should do, and we are doing them. We should reject the flawed phrase 'Cool Britannia', but recognize and assist the modern world of music, not because it might win votes or make a government look good, but because it is vitally important for our economy and for the achievement of musical excellence.

In the series of chapters and speeches that follow I am setting out to find the common thread of public policy that can begin to link all the creative aspects of society. I am asking what are the key features of a creative nation, why this should in any case be of any importance to individual citizens, and what – if anything – a government can do to help. And, in identifying the characteristics of a creative nation, I am also seeking to chart some of the astonishing progress that British creators are making at present. There is a resurgence in the extent and quality of creative activity in Britain, and no government can stand idly by and ignore the potential this has to uplift people's hearts and at the same time to draw in a major economic return to the country.

As a starting point, let us take a look at the diverse ways in which creativity now manifests itself, to the greater enrichment of all our lives. In his wonderful treatise on *Aspects of the Novel*, E. M. Forster once famously observed that we had to think of all the great novelists sitting down together, simultaneously, in a grand circular room, rather than as strung out along a flowing stream of time. Let us therefore in similar fashion draw together the enormous variety of ways in which creative impulse and production and performance and enjoyment manifest themselves in the Britain of today.

Take a look, for example, at the annual celebration of modern art in the Turner Prize exhibition at the Tate Gallery. Over the past twelve years the winners have included Howard Hodgkin, Gilbert and George, Richard Deacon, Richard Long, Anish Kapoor, Rachel Whiteread, Antony Gormley and Damien Hirst. And not only are these artists to conjure with on an international scale, but their work – and the work of all the finalists, each year – generates enormous public interest and public profile. Yes, the Turner Prize attracts huge controversy. Yes, it sometimes fails to recognize the very best: Lucian Freud was twice shortlisted but never won. But it stimulates debate, it draws crowds in vast numbers to see the exhibition, the award ceremony goes out live on television, and it demonstrates

beyond any doubt that there is a wealth of talent in Britain today, and that it is not just a supposedly sophisticated élite that wishes to share and enjoy the fruits of that talent.

You can demonstrate precisely the same quality of work, ferment of innovation and public interest in almost every field. From the skill of the City of Birmingham Symphony Orchestra, to the success of Opera North, to Deborah Warner's *Turn of the Screw* for the Royal Opera, to the huge popularity of Classic FM, the public appreciation of classical music is at an all-time high. Meanwhile, of course, British bands such as Blur, Oasis, the Prodigy, Pulp and the Verve dominate much of the rest of the world. Singers such as Roni Size and Jazzie B are putting black music on the map. And the British record and CD industry – as a result of the talent that lies behind it – is one of the great strengths of our modern economy.

In the world of fashion, British designers have taken charge in many of the top continental houses. London Fashion Week is becoming a major international event. And designers like Paul Smith are bringing the quality of their work to ordinary people across the country. In architecture, it is British architects who are being called on to design many of the great new monuments around the world, from 'le grand Bleu' in Marseilles to the renewed Reichstag in Berlin.

And of course design quality is not just about an artistic finished product; it is an integral part of the manufacturing cycle, and is increasingly recognized as such by industry. Britain is well placed to provide that integrated quality; it is no accident, for example, that half of the entire global design work of Daewoo takes place in Worthing. Producing quality that is pleasing to the eye, that is best fit for a finished purpose, and that produces the greatest operational efficiency, is becoming ever more important in manufacturing and in business. Cheapness – or, more importantly, value for money – matters of course. But design and quality act in synergy with value, and also help to stimulate the ultimate market for the product.

It is not only in design ideas that we seem to do well, but in product innovation and conception too. We tend to be brilliant at inventing things – from the television set to the jet engine to the computer – but rather less good at developing them into global success stories for British participants. Often we feed the rest of the world with ideas we ourselves have conceived, and then watch helplessly as others clean up the economic advantage. This brilliance at the start of the process, coupled with the failure to follow it through, is something that the Government is now seeking to address with the creation of the new National Endowment for Science, Technology and the Arts. Established initially as an endowment with Lottery money, NESTA will be about building the bridge between an idea and a product, between a skill and a career. It will help talent to make the break into the world at large. It will be about helping that follow-through process to happen. And it will be about pulling down the artificial barriers between science, technology and the arts, because in the worlds of new design techniques and multimedia and digitized images such barriers are becoming meaningless as well as counter-productive.

Meanwhile, in the audio-visual field, Britain continues (as it has always done) to produce the best radio and television in the world. It is hard to overestimate the benefit which we derive from having the BBC as a bastion of public-service broadcasting, able in an increasingly multi-channelled world to continue to act as a benchmark of broadcasting quality, or indeed from having the unique Channel 4 – a channel deliberately required to be different, one of the most astonishingly inventive things Mrs Thatcher ever did. (It is worth noting in passing the vital importance of the BBC continuing to act as the benchmark of quality in our broadcasting system, a role that will become ever more important in the face of a multitude of channels; as ratings share declines – which it probably will, albeit gradually – the quality role assumes an even greater significance.)

And the domestic film industry is undergoing a renaissance of

remarkable proportions. In 1997 double the number of British movies were made compared with previous years. *The Full Monty* has broken all previous records. *Bean* took in $100 million at the box-office before it even opened in America. And four of the top fourteen films seen in British cinemas during 1997 were British made. This represents an unprecedented market share, and our task now is to try to ensure that this is not just a one-off peak before we hit the troughs again, but part of a sustained improvement in the fortunes of British movie-making. That is why, alongside the assistance for production work through tax incentives, Lottery funds and new measures for Channel 4, we are seeking to ensure new support for scriptwriting, for training, and above all for marketing and distribution in the film industry. Backing for British film must go right along the chain of movie-making, from original concept to how it arrives on the screen.

British experts have also secured a lead in technical aspects of movie production, such as animation (giving us, after all, Wallace and Gromit) or computer graphics, and there is nowhere else in the world to go to get the best. The same is true of software preparation for computer games and of many parts of the publishing and advertising industries. Indeed, the need for continuing success for the publishing industry is one of the reasons – alongside the more obvious educational purpose – for the Government's firm commitment not to impose VAT on books and newspapers.

So it is undeniably true that, across the range of the things we see as making up the 'culture' of the country, there is a new mood of innovation and an enhanced participation in Britain. It is no accident, for example, that shortly before Christmas 1997 in France, national television devoted a two-hour prime-time programme to the 'new identity' of Britain as a hotbed of interesting creativity and modernity. This book sets out to explore how and why this is happening, and what this means for a progressive government wishing to help rather than hinder the process.

The raw figures confirm that the impressions derived from cultural observation are in fact true to life. If you compare the census figures for 1981 and 1991, and track the development of occupations in the cultural and creative sectors of the economy, as the Arts Council did in a major study two years ago, a startling picture emerges. There was, on average, a 34 per cent increase in the number of individuals with cultural occupations over the ten-year period. This compared with an almost negligible increase in the total economically active population over the same period. In other words, through the tail-end of the first recession and through the entire heat of the second, levels of employment in these creative occupations rose by more than a third. Clothing designers showed an 88 per cent increase; artists and graphic designers a 71 per cent increase; actors, entertainers, producers and directors a 47 per cent increase; and authors, writers and journalists a 43 per cent increase.

Interestingly, the growth was particularly marked amongst women. Between 1981 and 1991 the total number of women in cultural occupations increased by 69 per cent, compared to a 19 per cent increase among men. Indeed, the figure for women 'artists and commercial artists' rose by 135 per cent over the period.

As the census figures record changes that were happening nearly ten, or more, years ago, it is perhaps worth taking a look at four particular areas of activity, to see a more up-to-date picture. One of the problems in this whole area is that precise figures are hard to come by. The official collection of statistics is less good for these growing creative sectors than it is for the older manufacturing and service sectors. It is something the Government is currently trying to address with the 'mapping' work being undertaken by the Creative Industries Taskforce, to try and establish exactly what the employment, earnings, value and growth figures are for these industries, and to track them as effectively as possible. Many of these areas of activity are of course dominated by small and medium-sized companies, almost working on a cottage-industry basis, with a handful of

big players striding amongst them; it is a pattern that makes definition and accurate counting very difficult but even more essential, if public policy is to be properly determined.

The Creative Industries Taskforce has brought together for the first time all the various Departments of State that have something to contribute, be it the Department of Trade and Industry, the Foreign Office, the Treasury, the Department for Education and Employment or the Department for Culture. We are joined by a number of key people drawn from the industries themselves. We discuss together, in coherent fashion, the needs of the various industries and the ways in which government can assist. We have begun with the mapping exercise, to determine the extent of what we are dealing with, and the nature of the problems that need to be addressed. We have identified a series of issues, such as educational input, access to venture capital and copyright protection, which are of crucial importance and which we are now looking at in detail. This represents an almost unique exercise in government – cutting across the traditional divides of Whitehall, uniting government and industry in a partnership approach, and setting out an agenda of specific issues to be addressed.

The music sector is perhaps the best documented of the creative industries, partly because of the work carried out both by the industry's trade body, the BPI – the British Phonographic Industry – and the National Music Council. The best figures for 1995 show a full-time employment figure of somewhere between 90,000 and 115,000 people in music; part-time employment of around 70,000; consumer expenditure of between £2.4 billion and £2.9 billion; exports outstripping imports for every one of the last ten years; a balance of trade surplus of nearly two-thirds of a billion pounds; and a contribution to the balance of payments greater than that of the steel industry. One in five recordings sold worldwide has a British component, be it the artists, the composer or the recording company. And more British recordings are sold in the United States than American recordings sold in Britain. Nor,

of course, should we forget that music is not just an economic activity; it is an art form, bringing immense pleasure to nearly everyone. Recorded music accounts for just under 5 per cent of 'in home' leisure spending. Its percentage of 'in home' leisure time is probably rather greater. And its percentage of 'in home' enjoyment – if such a thing could ever be characterized by statistics – greater still.

Available figures for the film industry are more immediately up to date. In 1997, cinema admissions reached their highest level since 1974, with total box-office takings topping £512 million. The total number of admissions for the year were around 137.3 million, showing a 10.9 per cent increase on 1996. And this comes after a period of increased attendances in virtually every year for a decade and a half. Meanwhile British film production has increased dramatically during the same period, and the changes the new Government has put in place, with tax incentives for investment, film franchise funds through the Lottery, and the changes to the Channel 4 funding formula, will help to keep the production momentum up. The film production, distribution and exhibition sectors in Britain employ around 25,000 people. And British talent has carried off 30 per cent of all the Oscars awarded in the last twenty years.

British-produced films have also been taking an increasing share of the British box-office. Due to the American dominance in the movie market-place, this has always been difficult, especially because of the command of distribution and exhibition held by a relatively small number of companies; but in the recent past we seem to have broken through a ceiling. A week or two after Labour came into government, I spoke at the Cannes Film Festival of my ambitions for the British film industry over the coming years. Somewhat rashly, I thought at the time, I decided to set out a target for success. My aim, I said, was to see the British movie share of the British box-office double. I hesitated from putting a precise timescale on the ambition, because I was aware of how difficult it would be to achieve.

When I spoke, the British share was running at something like 9.5 per cent. As I write, in early 1998, it is running at 23 per cent. Little did I imagine that my wildest dreams would be more than realized in such a short period of time. The figure is, of course, attributable to a run of wonderful movies like *Mrs Brown*, *Wilde* and *The Full Monty*; and our challenge now has to be to try and sustain this remarkable performance.

In looking at the economics of the film industry, it is also important not to ignore the success of the video industry. The UK video market for 1996 amounted to almost £1.3 billion, with a retail market of £800 million – entailing some 79 million transactions – and a rental market of £490 million – involving 230 million transactions. Feature films, understandably, account for almost all the rental market but only about half the retail sales market. One of the most fascinating phenomena in all of this has been the interaction between consumption of videos and attendance at cinemas. When video arrived, and particularly when video rental began to take off as a major leisure activity, many people predicted that this would halt the upward march of cinema attendance figures. It did nothing of the kind. In fact, if anything there has been a slight acceleration in the upward movement of attendances. Far from detracting from the wish to experience the real thing on the big screen, the development of video-watching at home seems to have whetted the appetite for it. One of the lessons from this has to be that it is above all the quality of the creative experience that will drive these industries forward, not just the convenience or availability of consumable products.

If we turn to the television and radio industries, we can again see major economic and employment effects occurring. Television viewing and radio listening account on average for a remarkable 45 per cent of our leisure time. Revenues for television and radio – from licence-fee income, advertising, subscription and pay-per-view – exceeded £6 billion in 1997. Television and radio, in return, invested some £2 billion in original domestic production. Direct and indirect employment

from TV amounted to 68,000 people in 1996; this compares with a figure of 42,000 two years previously. With the development of a digital multi-channel future, it is likely that the value of the industry will grow to an annual figure of around £11 billion over the next ten years; this would mean reaching an employment figure of 100,000.

Exports of radio and television material have doubled in the last ten years, from £117 million in 1987 to £234 million in 1996. There are, however, some warning signs to be noticed in all of this. Although Britain has a language advantage over other European countries, it only exports 1 per cent more than Germany and France; and, whilst exports have doubled over the last ten years, imports have quadrupled. Whereas the balance of trade in radio and television programmes was in surplus in 1985, to the tune of a modest £24 million, it is now in deficit to the extent of £282 million, and this figure is rising fast. We are doing well, producing wonderful television, expanding our exports and receiving rave reviews from niche markets around the world, but we are still not doing well enough. The development of our original domestic production and the further improvement of our export performance have to be major priorities for the next few years.

Or, if you turn to the publishing industry, you will find growth from £11.5 billion of worth in 1990 to £17.5 billion in 1996, an annual rate of 3.85 per cent in real terms, well above the average annual growth rate of the economy as a whole. The book market has been steadily expanding, the magazine sector has been particularly strong, and the real surge has been in electronic publishing. Visible publishing exports reached £1.7 billion in 1996, contributing to a trade surplus of nearly £1 billion, and in addition net royalty income from abroad amounted to some £500 million. Total employment has fluctuated, but has now regained the levels of fifteen years ago, with productivity of course much higher. Print publishing accounts for 125,000 people in direct employment and a further 330,000 in related fields.

I have selected these four industries – music, film, radio and television, and publishing – because they are the ones for which some of the most detailed figures are available, and they do help graphically to demonstrate the recent successes of these creative sectors, but also the challenges ahead. (They also, incidentally, illustrate well both the possibilities for but also the limitations to governmental action.) With the inevitable hesitations that must attend such an exercise, it is just about possible to make some approximate estimates of overall activity in the 'creative economy' – that cluster of individuals, enterprises and organizations that depends for the generation of value on creative skill and talent, and on the intellectual property that it produces. This cluster includes music, film, television and radio, and publishing, of course; but also design in its widest sense, fashion, art, theatre, architecture, crafts, graphics, advertising, software, and journalism, amongst others. Broadly, it is possible to estimate that nearly 1 million people are employed in these industries. There are more than 1,000 businesses, and the annual turnover of them all, put together, is over £50 billion. This accounts for added value of some £23 billion, contributing almost 4 per cent of GDP. These industries have always formed an important part of our national life. But they also form an important, and increasingly significant, part of our national economy. It is vital that we do not lose sight of this fact, as we chart a way forward for government policy.

It is also vital, however, to remember that culture and creativity have immense intellectual, spiritual and social value as well as economic importance. One of the reasons for New Labour's election victory on 1 May 1997 was surely a very simple realization by the British people, after eighteen years of a contrary doctrine, that there *is* such a thing as society. A realization that we are in this life together, dependent ultimately on one another, sharing a common home and a common earth together, with responsibilities towards each other as well as to try and do the best for ourselves. A realization that we are not isolated individuals but that we achieve our own best fulfilment

in the interrelationship between the individual and the community of which we are a part. A realization that we have moved from a 'me' generation in politics to an 'us' generation of acknowledged responsibility. And a realization that we have our own sense of identity as individual people, but that we also share identities in our local or national communities, and that these various senses of identity are shaped and linked by cultural impulses and activity. Culture and the creative activity that gives it expression both play an essential role here. They help to define those links between the individual and society that form such a crucial part of the new understanding of politics. Without culture, there can ultimately be no society and no sense of shared identity or worth. For a government elected primarily to try and re-establish that sense of society that we had so painfully lost, this is a very important realization.

There have been times in recent months when some observers have argued that the British tend not to have a sense of social solidarity and cohesion; that when we do come together at a time of shared national emotion it is done out of mawkishness or sentimentality, not out of a joint shouldering of responsibility. I disagree. Heightened emotion can indeed sometimes play a part, and properly so – as it did, for example, at the time of Live Aid, or in the weeks immediately following the untimely death of John Smith, or in the outpouring of genuine emotion following the death of the Princess of Wales. But there are other ways, too, in which British people come together to express their belief in participation in society. Our enduring passion for the National Health Service, for example; or the flowering of voluntary organizations and activities in communities up and down the country; or our willingness to give blood without payment but with a sense of duty; or the seriousness with which we play music and act in plays and (in our millions) use the public library. We do very definitely believe in society; and cultural activity is part and parcel of that sense of community.

Creative activities, and the cultural experiences they foster, are expressions of the imagination. They are ways in which we

give form to feelings, and try to do so in a manner that enables others to touch and share them. The process of culture is almost by definition a process of communication; it is a drawing together of people to feel, to think, and to understand. The creator and the artist help to show us something about ourselves. This of course is vital for the binding-together of any community, and we should not underestimate the sheer importance of creative activity in helping all of us to move away from isolation.

The cultural process can cross continents too. I have, for example, proposed a millennium project for the European Union which would help to bring together the peoples of Europe in a shared educative experience that would improve access to culture in a very practical way. The idea is that all the great galleries and collections of Europe should put together in digital form the best of what they have, collected in CD-ROM and eventually online format, so that a great virtual gallery can be created. It should then be made available to every school in Europe, to become a real learning resource for children across the whole continent. This would surely be a valuable means of celebrating a common millennium and an increasingly shared heritage.

In exploring how culture and creativity can help to shape a *real* sense of community, can help to develop the links between the individual and society, I want here to develop two themes. The first is about the role of culture in civil society, and the part that government plays, or does not play, in facilitating that process. The second is the role of culture in economic society, something I have sketched out in the preceding pages but want to take further.

If culture and art are things that help to shape our shared identity, then there is surely a responsibility on government to nurture them. John Maynard Keynes put this well in a radio broadcast in 1946, when he described what he saw as the role of the then-new Arts Council: 'The purpose of the Arts Council of Great Britain is to create an environment, to breathe a spirit, to

cultivate an opinion, to offer a stimulus to such purpose that the Artist and the public can sustain and live on each other in that union that has occasionally existed in the past at the great ages of communal civilized life.' I am not sure that the Arts Council in the decades since has always fulfilled the whole of Keynes's vision, with a concentration – perhaps inevitably – on the grant-distributing functions of its role; but it is surely notable that he focused so firmly on the contribution to 'communal civilized life' that the artist, together with society, can make.

The nurturing that government must do to achieve this, however, must not be a process of dictating. It must, in a modern age, be a process generated from the bottom rather than imposed from the top. Patronage of culture by the state can so easily tip into prescription of content or form, and on the whole that leads to poor art. It was not always thus, of course. You have only to think of the Medicis in Florence at the height of the Renaissance, or of Van Dyck at the Stuart court in London, or of Velázquez at the Spanish court. Their subjects were determined for them, their patrons made their demands, and art was produced to order. The fact that it was the most sublime and creative art imaginable had little to do with the specified circumstances of its provenance. This has been less true of more modern times, where the tipping-over of patronage into state direction has almost always produced inferior material. Some of the monolithic statuary scattered around the grand old cities of the former Soviet bloc proves only too starkly the truth of that.

Getting the nature of state patronage right, therefore, is a careful and delicate exercise, but it must be done. To have a society in which there is no government support for the arts or culture would produce a very barren civilization. Of course there are many cultural activities that can thrive and survive on their own: the popular music industry is a fine example. But there are others, which involve innovative or difficult or new or esoteric work, where public subsidy is entirely justified. There are, I believe, five principal reasons for state subsidy of the arts

in the modern world: to ensure excellence; to protect innovation; to assist access for as many people as possible, both to create and to appreciate; to help provide the seedbed for the creative economy; and to assist in the regeneration of areas of deprivation.

Excellence, innovation, regeneration and access may be the main justifying purposes for modern state patronage, and between them they may provide the rationale for seeking taxpayers' support for something which not all taxpayers necessarily appreciate. But there is an overarching point too. A flourishing creative and cultural sector, and one which is supported by the body politic, is a symbol of a confident and energetic society. This has been true throughout history, whether the backing has come from above, as in Medici Florence or even in Jack Lang's France, or whether it has come in grass-roots fashion from the Arts Council of Keynes or the Arts Ministry of Jennie Lee. Because of the intimate links between cultural activity and the cohesiveness of a society, and because of the way in which culture helps to bind people together, the strength of a society or a period in its history is aptly judged by the strength of the artistic activity it generates.

There have been some who have, in recent months, expressed disappointment that we have not been able to make immediate and substantial new investment, as a government, in the arts. I understand the disappointment, of course. But to them I would say, first, look at what we have been able to do – from incentives for film to help for music in schools to securing free admission to some of our greatest museums and galleries. Consider also the additional £5 million that we were able to squeeze out of existing budget totals for the coming year, to provide a 'new audiences' fund for the performing arts, and thereby achieve an increase in Arts Council funding for the first time in years. Then I would say, please do not assume that everything can be done all at once. We took over a heavily indebted set of public finances from the outgoing government, and we deliberately said from the outset that we would be bound by the first two

years of inherited spending figures, in order to get the books into better shape. We have kept to that commitment, and it has sometimes been hard to do so. But it does mean that we can look forward to a better-planned future. Next I would say, some of the changes we want to bring in will take time; do not presume to judge the quality of the journey by the first few stations. Then I would point to the major improvements we are bringing in to the deployment of Lottery funds, touched on in some of the subsequent chapters: the ability to use Lottery funds more readily to support people and activities in the arts, sport and heritage field will transform the impact these substantial sums of money can have. We should not simply judge the virtue of policy by how much the Exchequer contributes. In the final analysis it is the full range of funds from all sources that matters; and the ability to devote Lottery funds more sensibly to help with stabilization grants, with the wiping-out of accumulated deficits, with one-off interventions to get arts organizations back on to an even keel: these will be of immense help in the arts world. And I would point, too, to the detailed work on structural change that is under way, looking at how we can get the best possible value out of every pound spent. Specifically, this means examining how we can reduce the number of consultants and overlapping layers of bureaucracy in the arts funding system, and seeking the best possible creative output for the money the taxpayer does actually contribute. There is a lot already happening, and a lot more to come, which demonstrates just how important and central to the Government's overall approach this area of activity actually is.

Getting the structure of the arts funding system right, so that it produces maximum creative value, has surely to be one of the major priorities. We also need, I believe, to encourage better administration generally across the arts world. Some organizations – like the National Theatre, or the Tate Gallery, or the City of Birmingham Symphony Orchestra – are very well run, with efficiency that does not diminish the high quality of performance, and with good income generation to set alongside. But

the same cannot, alas, be said of all. And I am very anxious indeed to ensure that efficient administration becomes as valued an aspect of artistic organization as creative and aesthetic power. I am not saying in any sense that it should supersede it. It should complement and reinforce it. Disseminating best practice, training good managers and encouraging improved administrative performance are all items that ought to be high on the list of cultural priorities.

It tends in fact to be artistic and creative activity that helps to define what Hazlitt called the 'Spirit of the Age'. The things that will be remembered about a period in history will often be a series of cultural milestones rather than automatically the political events that occurred. In his recent Leggett Lecture at the University of Surrey, Peter Palumbo put this enduring point rather well:

> But what of the Book of the Arts? Now here is the richest volume. The Arts define a civilized society; of that I have no doubt. The Book of our Contemporary Deeds would be quickly remaindered. In the Book of our Words much will survive. But the Book of the Arts itself would be in perpetual reprint . . . The Arts speak of abiding matters. The creative impulse springs from deep wells.

That impulse that springs from deep wells helps not only to put our stamp as a generation on the views of history. It also helps us to understand who and what we are, in the here and now, to capture that elusive sense of identity that gives us, either as individuals or as a nation, a sense of our place and purpose in the world. This was something that Paul Keating in Australia grasped at an early stage. Not only did he focus on a series of 'identity' issues – such as links with Asia, and the rights of Aborigine peoples – all of which are now coming back to haunt his successor, who had started out wanting to ignore them. But he also developed a series of policies under the 'Creative Nation' heading which involved real support for cultural activity precisely because it could play a part in securing an

identity for Australia and Australians in a way which had been for the most part lacking in the past. And he perceived also that the gradual loosening of ties between Australia and Britain, and the turning towards Asia which was almost inevitable given the country's geographical position, made the search for a sense of shared identity all the more important.

We, too, face at present a number of key 'identity' issues: our relationship with the European Union, for example, and the way in which we preserve our voice and standing and distinctiveness whilst playing a constructive part in the development of co-operation between member countries. Or the profound changes we are proposing for the nature of the British constitution itself: devolution for Scotland and Wales, regional assemblies in English regions where they are requested, a referendum on changes to the voting system, freedom of information, and a Bill of Rights to enshrine the European Convention in British law. These are substantial and far-reaching issues, and they all potentially have an impact on the way in which we perceive ourselves. The cultural thread running through all our thinking and all our self-perception will therefore inevitably become linked to the major political changes of constitution or adherence, and will help to define our approach to these areas of policy.

It is not only in relation to the openly 'identity-related' questions, however, that creative and cultural thought and action become relevant. In many of the areas of new political thinking – such as the fate of our environment, or the nature of lifelong learning and educational opportunity, or the need for equality to combat intolerance against minorities, or the development of effective measures to tackle social exclusion – there is a profound effect which culture has, or can have, in helping us to understand, then to feel, then to think, and then to act.

Cultural activity can help us with the development of our sense of who and what we are. It can help therefore to set a sense of direction for our society which would otherwise be

impossible. It can help us to make decisions on these great questions with our hearts as well as with our heads. It helps public policy, and in return public policy has to recognize that it must support culture.

In looking at the ways in which creative and cultural activity help to develop civil society, I would identify five specific roles. First, and perhaps most importantly, they can lead to personal fulfilment. This is partly an educative process, helping to draw out the imaginative thought and creative ability that is present in all of us. But it is also about helping to lead each and every one of us into a glimpse of a deeper world than that which exists simply on the surface. This was of course the great insight of the Romantics, 200 years ago. As Matthew Arnold subsequently put it, 'It is not Linnaeus or Cavendish or Cuvier who gives us the true sense of animals, or water, or plants, who seizes their secret for us, who makes us participate in their life; it is Shakespeare . . . it is Wordsworth . . . it is Keats.'

Or take the brilliant perception of J. H. Muirhead, writing about Coleridge in his book *Coleridge as Philosopher*:

'If the bend of a sunlit road, a bar of music, or the glimpse of a face suddenly thrills with romance, it is because these things have brought some unexpected revelation of the value of human life . . .' I think that this is profoundly true, but it requires to be added that what to the romantic spirit is of chief value in human life is the sense of the infinite which is implicit in it, and is the source of all man's deepest experiences.

This is where the individual fulfilment that comes from the act of creating, or the appreciation of the created experience, leads: to a sense of something that lies beyond the immediate surface consciousness, and that makes the real world more real still.

That in itself would of course be justification enough for an acknowledgement of the role that creativity can play. But there are other reasons besides. The second is the sense of identity and

self-worth that can stem from creativity and the culture that creativity puts together. Personal identity, of course, comes from that process of fulfilment I have just described. But beyond that are the processes of cementing a community identity – whether of a family or a neighbourhood or a group – and then by extension the national or even international identity that lies beyond. These are fundamentally cultural definitions, and the creative work that gives birth to culture leads to the development of identity too.

Third, creativity helps – by drawing people together and enabling them to share emotions – to ensure social inclusion, and to overcome isolation and rejection. This is the social impact that I have already identified, and runs alongside the development of a sense of wider identity that takes us beyond ourselves. Fourth, creators pose us with challenges; they are motivators of political and social change. Chekhov once observed that the role of the playwright was not to solve problems, it was to ask questions. This is true of much of the creative world. It is not there to make anyone feel warm and cosy; it is there to ask, to probe, to challenge, and to be awkward. That in itself is a fine social purpose.

And fifth, creativity helps to unify the concepts of use and beauty. This is what William Morris dedicated his life and art to achieving: the notion that a thing of use could be a thing of beauty too. Design, craftsmanship and artistic flair are all attributes that a creator brings to an object above and beyond the utilitarian approach that looks simply at the way something is used, rather than the qualities inherent in it. Linking quality of design with usefulness of purpose is the task of the creator, and the best creators make it seem as if they are one and the same goal.

These, then, are the principal contributions that creativity makes to civil society: fulfilment; identity; inclusion; challenge; and useful beauty. But it is not just as a contribution to civil society, however worthwhile, that creative activity and culture need to be judged. The role of creative enterprise and cultural

contribution in a modern world is a key economic issue, as well as a social one. Given the levels of growth already experienced in these fields, given the flow of changing technology and digitization, given our continuing ability to develop talented people, these creative areas are surely where many of the jobs and much of the wealth of the next century are going to come from. The value stemming from the creation of intellectual property is becoming increasingly important as an economic component of national wealth. As the concentration on the production of goods and even on the provision of services becomes less intense, so the development of creative value will increase. This has been gradually happening over the last ten years – or in some cases not so gradually, as the figures I have already referred to have indicated. And it is likely to continue during the coming decades too.

There are a number of explanations for this. I would point to four in particular. First, the apparently innate creativity of our people. We appear to be rather good at writing, designing, painting, composing and inventing. Perhaps it is that strange combination of seriousness and irreverence woven into some of our national character that leads to this, but something seems to. Second, we have strong traditions – culturally rich in broadcasted material, a public-library service that gives access to the written word, a popular-music tradition that has swept across the world, and excellence in theatre that we all too often take for granted. Third, we are living through a revolution in forms of communication, with the development of new multimedia expression and digital access. The availability of information, more readily and in far greater quantities than ever before, has exploded many of the old assumptions we used to have about the ways of the world. And fourth, we speak English. Some 80 per cent of all the digital communication that takes place worldwide happens in English. English has become the *lingua franca* of the Internet, of software composition, of music and movies, of business transactions. As David Puttnam has put it, we now live in an island of creativity surrounded by a

sea of understanding – and the understanding comes from the language that we have bequeathed to much of the rest of the globe. The English language in which, by and large, creative communication occurs around the world provides us with a real headstart in virtually all of these fields. We must beware, however; the English language can always be hijacked from us by others, just as has happened to virtually every invention we have made in recent years. We cannot simply sit back and assume that our authorship of the language will see us through. It will not, even though it does give us an inherent advantage.

We must determine to make the most of these strengths of ours. That is why, as a new government, we have recognized the importance of this whole industrial sector that no one hitherto has even conceived of as 'industry'. It is why we have gathered government and industry together in the Creative Industries Taskforce, to set out a programme of work to help to make these successful areas of enterprise even more successful. This is not in any sense to downplay the importance of the traditional nurturing of cultural and creative activity; indeed, that is even more vital because it is the seedbed from which the creative industries spring. But it is to recognize fundamentally that the intrinsic cultural value of creativity sits side by side with, and acts in synergy with, the economic opportunities that are now opening up.

In setting out these social and economic purposes, both important, both essential, I return again to the four key themes that form the heart of the Government's policy approach and that will emerge as common threads through the speeches and chapters that follow. We want to broaden access: the ability to create, the chance to enjoy the fruits of creativity, must be – as far as is possible – available to all. We must encourage excellence: accessibility does not mean, and must not be allowed to mean, a diminution of quality or seriousness or value. We must develop the educational role that creativity can and must have, not just for children but for adults through life too, so that the individual fulfilment and the social identity that

can come in train can be attained. And we must support the creative economy, because there is growth and vibrancy and opportunity for many people in these areas of work.

These, then, are some of the reasons why creativity is so important. Why any government that is thinking seriously about the future has to address the issue of how it will recognize and support the role of creativity in nurturing society, and of society in nurturing creativity. Why creative activity and culture are necessary for social cohesion, for economic success, for personal fulfilment and freedom. Yes, unlike Blake, we must learn to reason and to compare. But, like Blake, we must learn to create – because if we fail to do so, or, even worse, fail to make the attempt, we will ultimately be enslaved.

Culture Value:
The Creative Industries in Britain

A speech to the Thirty Club at the Savoy Hotel, London, on 13 January 1998

I want to talk this evening about creativity and the enjoyment of creativity, and about its growing economic importance. But first let me stress that the creative and cultural value of experience and activity is important simply and solely for its own sake. When we thrill to some bars of music, or become entranced by the power of theatre, or feel the magic of story-telling at the movies, these are moments that help to shape our sense of our own identity, and that help – undoubtedly help – to make life worth living. They are all dependent on creative skill and talent. But they are more than just enjoyable, and moving, and challenging. They have great *economic* importance too. And creativity lies at the heart of that importance.

The creativity of the British people is one of our greatest strengths. It has shaped our culture and our position in the world. Since the days of the great Renaissance explorers, scientists and philosophers, the British economy has been driven by a restless quest for discovery and innovation. The Industrial Revolution put Britain at the forefront of the world economy, by harnessing the new tools of economic power – roads, bridges, shipping, railways, industrial machinery and processes. These all relied in the first instance on the inventive power of imagination: the creativity of the idea leading on to the more technical job of management and development that then took these vast processes forward. Perhaps where some of the fruits of the Industrial Revolution went wrong was when

people forgot about the empowering process of ideas and relied on mechanical development to bring improvement.

More recently, of course, British innovation and creativity have played a central role in the relentless process of globalization. The telephone, the television, the jet engine and the computer are all contributions that British-born inventors have made to the shrinking of the globe. A recent Japanese government study concluded that, of all the products that have fuelled the Japanese economy in the last twenty years, some 40 per cent have originated with British ideas.

The revolution continues. The age of the PC, of the Internet, of the communications satellite and digital technology, is the greatest period of change since the steam age. Its consequences for Britain and the world are just as far-reaching. So, to compete in today's world, we must be a truly modern nation. And that means we need the creative talents of the British more than ever.

Our scientists must equip us with the fundamental knowledge we need to understand and harness the powers of new technologies, and to deliver those powers in ways that facilitate (and not alienate) human use; and they must be at the forefront of the quest for the next generation of discoveries. Our inventors, designers and engineers must give us the right tools for the job. They must spearhead the exploitation of those new technologies. They must design for efficiency and for aesthetics. They must be able to develop their ideas into marketable products, designs and services to sell in the global market, so creating wealth and investment at home. And our creative artists and musicians must assist that process of design, and must be recognized as among the foremost in the world, equipped to tap expanding international markets.

The inherent creativity of the British people has never been in doubt. In recent times, however, we have failed fully to exploit its potential. We have been brilliant at having ideas, but nowhere near as good at using and developing them. Too many British innovations have been developed overseas because of a lack of financial backing for them here. Too many British scientists have

left to continue their pioneering work in foreign laboratories. And too many young people with talents in science, technology and the arts have found the way barred to them.

If we do not nurture our creativity, we have no right to suppose that it will flourish or that we will see its benefits. It is to ensure that we enjoy the full benefits of our creative potential that the Government has proposed the establishment of the new National Endowment for Science, Technology and the Arts (NESTA), which I would describe as a 'National Trust for Talent'.

NESTA will have three objectives. The first will be to help talented individuals to develop their full potential. Working with and through other bodies, NESTA will aim to identify and nurture talent, investing in the young people who are the future of our nation.

The second objective will be to turn creativity into products and services which we can exploit in the global market. We must not leave others to benefit from our own creativity. NESTA will help create the environment in which the fruits of innovation are reaped here in Britain.

Thirdly, NESTA will advance public appreciation of the creative industries, science and technology. NESTA cannot alone provide all the backing a creative nation needs to succeed. We need a change in the attitudes of the public and of business, a wider recognition of the vital economic importance of national creativity.

NESTA will receive an initial endowment of £200 million from the National Lottery, to invest for the benefit of future generations. The expected income from that endowment will instantly make it one of the top ten grant-making trusts in the country. But it will also seek further donations and contributions to the endowment, and the gifting of future royalties from those whom it helps to get a career or product off the ground. It will seek contributions of time and talent from businesses and individuals, and will look for organizations with which to form partnerships in pursuing its objectives.

Incidentally, whilst on the subject of corporate donations, I would note in passing that the figures out tomorrow from ABSA – the Association for Business Sponsorship of the Arts – show that the total amount of business donation to the arts in 1997 was an all-time high of £95 million; this compares with £0.5 million twenty years ago. And, increasingly, businesses are finding that the creative team-working approach of many arts organizations can give them an added business edge. The process of donation becomes a two-way benefit. The major company which sent all its senior executives away for a weekend to produce an opera together, under the auspices of an arts body it supported, discovered that there was an enormous gain to the company when they returned.

During the past few years in Britain we have seen an incredible flowering of the creative industries: of those industries that rely on individual skill and creative talent for their added value. They include advertising, architecture, arts and antiques, computer games, crafts, design, fashion, film, television and radio, music, the performing arts, publishing and software. They represent over £50 billion worth of economic activity in the course of a year. Some £12 billion of this is earned from exports. They earn more revenue at home and abroad than the whole of manufacturing industry. And the sheer scale of these figures tells us something about the great sea-change that has occurred in the British economy over the past twenty years. These industries, many of them new, that rely on creativity and imaginative or intellectual property, are becoming the most rapidly growing and important part of our national economy. They are where the wealth and the jobs of the future are going to be generated from.

British film- and programme-makers, writers, musicians, visual artists and software designers must therefore be equipped to make the most of the vast international market that is opening up. They must be highly trained in the skills of their art, to rank with the best in the world. They must have access to and knowledge of the potential of new creative technologies. They

31

must understand the demands of new audiences. They must be supported by the most modern communications infrastructures. And they must be able to protect the intellectual property rights on which their businesses are built.

Government of course has a role to play. No government can or should try to second-guess creativity. But a government can put the right framework in place. We must ensure that our policies across all government departments properly recognize the economic importance of the creative world, and reflect its needs in order to maximize the benefits. That is why the Prime Minister has asked me to chair the Creative Industries Taskforce, bringing together ministers from right across government and senior industry figures. The aim is to offer, for the first time ever, coherent support for all of these industries, rather than just bits and pieces of occasional help and frequent hindrance.

The Creative Industries Taskforce has already started on a wide-ranging programme of work. We are mapping creative activity in Britain, and assessing its economic trends and potential. We are examining how government policies affect the economic performance of the creative industries. We are exploring whether the provision of education and training, in our schools and colleges, is properly equipping people for employment in the creative field and for starting new businesses. We are looking for ways of improving access to venture capital, and of ensuring that support for small businesses adequately takes account of the particular needs of creative people. We are closely following developments in the implementation of the World Intellectual Property Organization treaties on copyright, and measures to combat piracy. We are looking ahead to ensure that the UK industries are properly equipped to exploit fully the potential of new technologies. And we are examining how the support government itself offers to businesses with goods or services to export can be better targeted on the creative industries.

I particularly want to emphasize the importance that I attach

to the nurturing and development of creativity through the education system. In these creative industries, the raw material for economic success is one thing: people. It is the skills and talents developed over the school years and beyond that determine whether a particular individual is going to have something to offer. We must always keep in mind that, through school and college and lifelong learning, there is a need – alongside the basics and reason and logic that are taught – for the nurturing of the spark of creativity too. It is important, of course, for individual fulfilment; but vital for our economic success as a country as well.

I have been greatly encouraged by the very positive reception which the Creative Industries Taskforce has received. The agenda we have set has generated widespread debate. I believe that, together, with government and industry working in partnership, we can give our creative industries the best possible chance to meet their full potential in the new millennium.

Only Connect:
Culture and our Sense of Identity

A speech for the Fabian Society Conference at the Playhouse Theatre, London, on 19 September 1997

Robert Kennedy once wrote: 'The Gross National Product does not allow for the health of our children, the quality of their education or the joy of their play. It does not include the beauty of our poetry or the strength of our marriages, the intelligence of our public debate or the integrity of our public officials. It measures neither our wit nor our courage, neither our wisdom nor our learning, neither our compassion nor our devotion to our country. It measures everything, in short, except that which makes life worthwhile.'

I am not sure he was entirely right, because he was ignoring the strands which were already developing then, in the 1960s, of interconnection between culture and national economy to which I shall turn in a moment or two. But he was pointing with characteristic forcefulness to a profound truth: that there is a bundle of emotions, experiences and defining elements in all our lives that cannot be pinned down in mechanistic terms, that cannot be counted by an accountant, that cannot be readily measured in a calculus, but that together make up the most significant components of our character, and of our purpose. These elements form themselves into what we might call our own individual culture, our own sense of identity and self-worth; taken broadly together, across groups of people they represent what can more generally be seen as the culture of a community or a nation.

These are almost impossible things to pin down with

precision. If you ask for the meaning of the word 'culture', you will receive as many definitions as there are definers. It is a bit like the word 'socialism', I suppose: it can accommodate as little or as much as the user wants. It can encompass the whole history of a people, or their current way of life, or their ideas for the future, or their religious beliefs, or the corpus of their thought or their literature or their music or their art. Matthew Arnold defined culture as 'the acquainting ourselves with the best that has been known and said in the world, and thus with the history of the human spirit'. I have always thought that this – fine concept though it is – has tended to place culture too formally outside the experience of the individual in some great intellectual tide that is seen as being divorced from the personal and that has to be struggled for and connected to before it becomes valid. I prefer to follow Kennedy in seeing culture as 'that which makes life worthwhile' – both as individual human spirits and as communities.

As someone rather neatly put it to me, when I migrated from being the Shadow Health Secretary to being (as it then was) the real Heritage Secretary, 'Health is a *sine qua non*, but culture is a *raison d'être*.'

No one who has lived through the last three tragic weeks here in Britain [following the death of Diana, Princess of Wales] can doubt, either, that there is such a thing as a national cultural sense, as well as a series of individual cultural experiences. What we have witnessed, I believe, is a real feeling that we are coming together as a nation, in shared grief but in shared purpose too. I felt it a little bit in those terrible weeks three and a half years ago when we lost John Smith, when suddenly the values of social justice to which he was so passionately devoted swept through the national psyche and became the normal stuff of political discourse in a way that would have been inconceivable before. On a larger scale we are seeing something of the same happening now. The death of the Princess of Wales has unlocked a depth of emotion that we scarcely knew we felt: of compassion and commitment to those who are marginalized

and disadvantaged; of informality and a touch of irreverence; of respect for vulnerability; and of wanting to be part of something bigger than ourselves. What a change this represents from the go-getting, me-first, thrusting Thatcherite world of 1980s values.

We must be careful, however, not to run away with the notion that there is some sort of monolithic British culture that shapes one form of national identity and one only. How can you possibly describe our national identity? Is it warm beer and the sound of leather on willow and 'old maids' bicycling through the morning country mists to communion? Is it what goes on in Albert Square or Coronation Street? Is it the Notting Hill Carnival? Is it the crowd at Wembley rising silently to 'Candle in the Wind', or roaring at the goals that followed? Is it Italian opera at Covent Garden, Scandinavian plays at the National Theatre and Russian music at the Proms? Is it wallowing in the mud at Glastonbury? Is it marching down the catwalk in Paris, or designing a new gallery in Stuttgart?

It is, of course, all of these things and a great deal more. Culture – or perhaps we should talk rather of cultures – has to be seen on the widest possible canvas. Today Britain embraces cultures from all over the world, as it always has, and the diversity of our society and of our experiences is precisely what makes for the richness of our cultural environment. Many parts of those cultures that we have gradually absorbed have already become so familiar to us that we no longer think of them as foreign at all. Someone hearing a sitar or South African close harmony on the radio immediately accepts it as music, not foreign music, in the same way that we have as a nation widened our gastronomic tastes over recent years, drawing on the best culinary effects of a wide range of traditions. So when we try to understand how our national culture and sense of identity intertwine, let us remember first and foremost that diversity is one of the key ingredients of both that culture and that identity.

In this interweaving of cultures in Britain, there are now so

many different voices that help to give us a new and modern identity. Just think of writers such as Ben Okri, Salman Rushdie and Kazuo Ishiguro, bands such as Massive Attack and Eternal, singers such as Roni Size, Jazzie B and Apache Indian, imaginative new fashion designers such as Ozwald Boateng. All these are new ambassadors for a new creative Britain. And all contribute to a diversity we should be shouting about from the rooftops.

Sitting side by side with the concept of diversity, is another equally important characteristic of our national culture: that it spreads – or should spread – across the *whole* of society. Cultural experience and activity must, I passionately believe, be available to the many and not just to the few. If I had to identify a defining motif of our new Government and our new Department for Culture, Media and Sport, it would be precisely this. That developing our own individual sense of identity through cultural experience, and touching a sense of shared identity through shared cultural emotion, must be achievable by everyone, no matter what their circumstances or class or background or location may be. Things of quality must be accessible to all.

That is, in my view, a legitimate aim of government. No government can or should attempt to create culture, or dictate what its components are, but governments can help creative impulses to flourish, and can ensure that as many people as possible have the chance to enjoy and absorb.

There is a perpetual danger that 'culture' will be seen as something alien to the vast majority of people, something just for an élite and for special people in privileged places. We must fight as sturdily as we can against such notions. I have said on many occasions that culture, the arts, sport, enjoyment of creativity are for all. I have also said that they must become much more a part of everyday life, not just reserved for special events. Both points are central to any understanding of how our sense of ourselves as a people can develop. But there is a further point to add, too. We must not define ourselves solely in terms

37

of the past, or tradition, or what we have inherited. Culture and personal and national identity are every bit as much – if not more – about the future, as they are about the past.

That is one of the reasons why I felt it was important to change the name of my Department. Important though the conservation of our heritage is, it did not represent the whole thrust of what our work should be. I wanted something that was a bit more all-embracing, and a bit more forward-looking. Our new title reflects much more the modern nature of what we are about.

This is something we perhaps need to take note of as a nation, too. The recent Demos work is frightening in the evidence it amasses about the way in which as a nation we look backwards – and the impact this has on others' view of us, as well as on our own view of ourselves. Japanese consumers have a higher regard for British products than we ourselves do. Only 37 per cent of eighteen to thirty-four year olds believe that Britain 'is a better country than other countries'. British companies are dropping the word 'British' from their titles. And the Demos authors drily tell us: 'Around the world . . . Britain's image remains stuck in the past . . . Britain is seen as a backward-looking has-been, a theme-park world of royal pageantry and rolling green hills, where draught blows through people's houses.'

That is the perception, though I suspect it is changing for the better in a way that the Demos polling work has not yet picked up. But contrast that with the reality. We export more per head than the USA or Japan. We lead the world in many of the new and growing industries, in design and fashion and music and computer graphics and the audio-visual field. Eight out of ten of the most profitable retailers in Europe are British. We have the busiest international airport and we host the largest international arts festival in the world. London buzzes with life and energy. Some 1.4 billion people live in countries where English is an official language. These are strengths. They are pointers to our future sources of wealth, and to our potential sense of pride

and identity. But we have to play to these strengths, and this is where government can help.

Next Monday the British Tourist Authority will be launching its new logo, and I will not break embargoes by mentioning here what it is, save to say that I think it is **rather** good.[1] But the research that led up to its development is **very** significant. In all the survey work amongst visitors, and **potential** visitors, to Britain, two contrasting themes **constantly** emerged: that Britain was a place of tradition, and that **Britain** was a place of innovation too. Pomp and pageantry **alongside** modernity. We are of course a nation that is both buttressed and circumscribed by our history. This is true of every European country, in a way which North America and Australia, for example, are not. Nearly every piece of ground in Britain has been worked on, lived on, loved and changed, over the centuries. Nearly everything we do has gradually evolved from things that have been done before. This is a simple fact of life. It is a strength, and it is also a limitation. But what we need to do is to use this platform of history and tradition in order to build a new and innovative future. In many fields of human endeavour we are now seeing a real renaissance of activity and imagination, here in Britain. It is true in everything from the performing arts to medical science. Let us make sure that, in setting out for ourselves a new sense of our culture and our identity, we keep fully in view the synergy between tradition and innovation that is almost unique to us, and that can give us a real edge for future economic success.

Nor should we ignore the importance of cultural activity and development for social regeneration. Some of the recently published Comedia work has shown this particularly strongly. Work to provide cultural opportunities – in the arts or theatre or multimedia or sport – in local communities can be easily the

1 The new British Tourist Authority marque was indeed launched the following week, and has been broadly welcomed. It uses the Union Jack in an informal way, against a background of blue, green and gold, and seeks to capture both the heritage of the old and the innovation of the new.

most effective way of providing a spur to the wider regeneration of a neighbourhood or an estate. Providing cultural opportunities, for local people to enjoy themselves, to find fulfilment, to develop skills they never realized they had, and to experience the excitement of working together with others to make things happen, all help to generate a sense of purpose and of self-worth amongst those who have been constrained or patronized for years. This is a classic demonstration of the links between cultural activity and a sense of identity to which I referred at the outset. And it can lead on to the most remarkable rejuvenation of neighbourhoods in other ways, too. Look at what has happened in areas all around the country, where music workshops or mural projects or creative-writing schemes or mini-festivals have been put together on a small scale, but with enormous benefits for everyone involved.

Without education, however, there can be no culture. Education is all about the best possible individual development for a child. It is about finding fulfilment and honing skills and equipping yourself for the world and becoming a citizen. It is also about becoming a full person. In order to achieve all of this, we must not and cannot ignore the cultural aspects of education. A very young child finds something magical, something wonderful, about singing and dancing and painting, and relating to the world through the medium of what we as adults would recognize as cultural activity. Yet, whilst much of our subsequent educational provision for that child is about logic and reason, we must never let the magic be suppressed. I want to ensure, naturally, that high standards in the basic skills of reading and writing, and counting and relating to others are attained. But I also want the magic and wonder of the world of culture to be there too, alongside the other skills that are being learned and perfected. Without that, fulfilment will not come and society as a whole will be the poorer for it.

Nurturing our sense of culture in ourselves and as a society; cherishing diversity; ensuring that the opportunities to do so are available to all; building on our inheritance to shape an exciting

future; recognizing the economic and social success that can come when married to a sense of culture; and ensuring that our education system encourages such a development: these are the key themes for anyone – particularly a government that dares to consider itself civilized – interested in enabling a proud sense of cultural identity to lead to a proud sense of national achievement.

Sheila McKechnie, chief executive of the Consumers' Association, recently remarked that the word 'culture' represented for many people something that you grow tomatoes in, or something you grow viruses in; but that it was actually something you can grow people in. Or rather, something in which people can grow themselves. That, after all, is what this is all about. And I believe there are enormous possibilities here for us to get it right.

A Vision for the Arts

Adapted from a speech to the Annual Dinner of the Royal Academy, London, on 22 May 1997

One of the defining differences between the parties at the recent general election was this Labour Government's fundamental belief that the individual citizen achieves his or her true potential within the context of a strong community. For years the absurd assertion that 'there is no such thing as society' held sway. That philosophy brought about a palpable decline in the quality of communal and personal life in Britain; and our first aim must be to rebuild – piece by piece – the nation's sense of community. Our cultural life – embracing artistic and sporting endeavour, the quality of our media and the sense of our heritage – has a key role to play in this. It is culture in its widest meaning that gives us our sense of identity. It draws us together. It enables us to understand and to articulate our experiences, our values and traditions. It opens up our minds. It helps to make life worth living.

For too long governments have considered the arts as something of a sideshow, an add-on to the main business in hand. I strongly dissent from this view. Enhancing the cultural life of the nation will be at the heart of New Labour's approach. The arts are not optional extras for government; they are at the very centre of our mission.

It is surely sad that governments for many years have failed to understand this simple truth. We have many inspirational artists in Britain; our theatres draw audiences from around the globe; our film-makers and television programme-makers are world

leaders; our designers and architects are in universal demand; our music industry goes from strength to strength. Yet recent governments have shied away from giving arts and cultural activity either the importance or the support they need.

Other administrations have, by contrast, recognized the importance of cultural life to their people. In France, the transformation of Paris over twenty years has given an enormous sense of civic pride to its citizens. In Australia, Paul Keating deliberately set out to forge a new sense of Australian identity from cultural endeavour. And here in Britain, when Jennie Lee was appointed as our first ever Arts Minister by a Labour government, we saw the flourishing of cultural life in a way undreamt of by earlier generations.

It is my passionate belief, therefore, that there is a duty on any civilized government to nurture and support artistic and creative activity, and to put in place the conditions in which the arts can thrive. In doing so, I want to set out four cardinal principles against which that commitment is given.

The first – and perhaps the most important – is that the arts are for everyone. Things of quality must be available to the many, not just to the few. Cultural activity is not some élitist exercise that takes place in reverential temples aimed at the predilections of the cognoscenti. The opportunity to create and to enjoy must be fostered for all. Enjoyment of the arts – be it of Jarvis Cocker or of Jessye Norman, or Antony Gormley or Anthony Hopkins – crosses all social and geographical boundaries. The arts fire the imagination and inspire the intelligence; there can be no artificial barriers erected to prevent or discourage access to those experiences.

Take an obvious and current example: the availability of world-class opera at the Royal Opera House in Covent Garden. I believe strongly that London needs a first-rank, globally recognized venue for opera. I think it is right for us to ensure that public support is available to it. But I want to see better access for the ordinary people of Britain in return for that support. That is why the commitments already given, for some

cheaper seats and for more television broadcasting, are welcome. Let us see how we can build on those.

And let no one try to tell me that the appetite is not there. Look at the barnstorming success of Classic FM. Look at the crowds waiting in the rain for Pavarotti in Hyde Park. Look at the great surge of public interest when the GLC so marvellously opened up the foyers of the Festival Hall to the public. Look at the sheer pressure of visitor numbers that has led to the Tate Gallery having to close its doors from time to time at weekends because there are too many people inside. And listen to my own constituent, chair of her tenants' association for the last ten years, who told me – after hearing an opera singer who had come to sing some arias for a local Christmas concert – that she had loved opera for years, she had a stack of tapes at home, but she had never seen an opera singer performing live, ever before. Let us aim to make that exclusivity a thing of the past.

I have been impressed, too, by the way in which some of the Lottery awards have recently been moving in this direction. The Arts for Everyone programme has now begun to put small-scale grants in place at community and neighbourhood level, fostering local artistic activity in a way that has a real impact on people's lives. I welcome this enormously, and wish to give every encouragement to the Arts Council – and to the other distributing bodies – to continue their emphasis on grass-roots projects and local schemes. The Lottery, after all, is the people's money. More of it should go to where the people are.

This brings me to my second major theme. It is a related and important point. I spoke earlier about ensuring that the arts were not simply associated with activity in special – sometimes intimidating – temples. Of course there is a bit of magic to be preserved, but not to the exclusion of the enjoyment of creative flair in the most accessible settings. In short, I want to see the arts becoming much more a part of our everyday lives. You should not need always to make the conscious decision to step across a special threshold in order to experience cultural activity. Art, and good-quality design, and architecture that

arrests and pleases, and cultural enrichment should be part and parcel of everything we do and everywhere we go. I want to encourage cultural activity to come to the people, rather than always expecting the people to go to the activity.

Think, for example, of the way in which Northern Arts – in its hugely successful Visual Arts 96 programme – turned a number of carriages on the Gateshead Metro into travelling art galleries. You would not know when it was going to happen, but from time to time, on your journey to work or to the shops, you would step into a carriage that had been transformed. Think also of the wonderful work that Hospital Arts in Manchester has for years been doing, bringing artistic pleasure to patients in local hospitals. The changed face of Birmingham's city centre by the imaginative use of public open space and bold sculpture has been dramatic, too.

Let us try, over the coming years, to put more energy and thought into how we can transform our public spaces, our street architecture, and our creative activity. Let us consider public-art projects – not ones that dump an unwanted sculpture in the middle of a much-loved high street, but ones that involve local communities in creating fine spaces. And let us consider bringing live art and contemporary painting and sculpture to some of those places we have to be in or at – the office block, the shopping mall, the airport waiting lounge. Would it not be good if we could turn off the Muzak and have some live music for a change?

My third theme is the enormous economic importance of the creative sectors. As I have said elsewhere, the arts, sport, media and cultural industries together amount to some £50 billion of economic activity each year. Some 500,000 people are employed in the arts sector alone. The arts represent a massive boost to local economies: when the new Tate Gallery opened in St Ives, the levels of economic activity in the town rose by 25 per cent almost overnight. Cultural activity, therefore, has an important contribution to make in working towards our goal of high and sustainable levels of employment. This is why I am particularly

anxious for the cultural sector to play a full part in our Welfare to Work programme, helping young people in particular to come off benefit and into work or high-quality training.

The fourth and final theme I would put in place is simply this: we need to ensure that the arts and creativity are made an integral part of our education service, above all for young people, but throughout the whole of life as well. Our education needs to teach us to reason and to question and to analyse, but it needs to teach us to wonder too. And the arts are central to this.

For any of you who have never done so, I recommend a trip to the Micro Gallery computers in the Sainsbury Wing of the National Gallery. There you will see young people – and those young at heart too – sitting in fascination, gripped by what they are seeing on the screen in front of them. Here is the most important thing of all. Having chased the digital image round the screen for a while, they then want to go and see the real thing. And their experience of it has been enormously enriched by what they have just learned.

That, I believe, is art in education at its best. It is why I want to see a digital archive emerging in this country, taking the best of all the great national collections we have, putting it into on-screen form, and then making it available free to every school and every public library in the country. The idea is that any pupil, anywhere in the land, can walk into their classroom, sit down at a computer, and conjure up in seconds the glories of the Science Museum or the Tate Gallery. And the glories too, I hope, of the Royal Academy.

I have tried to set out tonight some of the vision I have of how public policy on the arts can develop in the years ahead. The arts for everyone; part of everyday life; economically vital for the nation; and part and parcel of our education system. These are bold objectives. But let us never forget that the primary joy of art is the value it has, of and for itself.

William Hazlitt, two centuries ago, put it better than I possibly could. He was perhaps a little hard on the Scots, but he made the point very movingly:

Scotland is of all other countries in the world perhaps the one in which the question 'What is the use of that?' is asked oftenest. But where this is the case, the Fine Arts cannot flourish, or attain their high and balmy state . . . for they are their own sole end and use, and in themselves 'sum all delight'. It may be said of the Fine Arts that they 'toil not, neither do they spin', but are like the lilies of the valley, lovely in themselves, graceful and beautiful, and precious in the sight of all but the blind. They do not furnish us with food or raiment, it is true; but they please the eye, they haunt the imagination, they solace the heart. If after that you ask the question, *Cui bono?* there is no answer to be returned.

All the World's a Stage:
Culture, Business and Society

From a speech at the Royal Shakespeare Company Conference at the Connaught Rooms, London, on 1 December 1997

At the heart of today's discussion lies a tripartite relationship. The arts, business and society all interact, and all derive support and enlightenment and life from each other. I want to explore these themes in greater detail, and in particular to reflect on the role that government can and must play in assisting the development of these relationships. But perhaps I can begin by noting how appropriate it is that the Royal Shakespeare Company – such a major and important part of the cultural life of this country, and such an exemplar of good relationships with the business community – should be hosting this conference. I am grateful for the opportunity that has been provided by the RSC to contribute some thoughts.

My starting point is simple. It is my firm and passionate belief that it is a duty of any civilized government to nurture and support artistic and creative activity. No government should ever forget that. For too long in this country the arts have tended to be considered as something of a sideshow, off at the side of the stage, not part of the main action, the 'real' business of running the nation's economy. I shall return in a moment to the issue of the impact of the arts on the economy; but let me say here and now that the cultural life of the country – embracing the high and the popular arts, the success of our sporting endeavour, the quality of our media and the sense of our heritage – is increasingly going to find itself at the centre of this Government's vision. No longer seen simply as

an optional 'add-on', but at the heart of what we are about.

Anyone looking into a society from the outside – whether geographically or with the benefit of historical hindsight – will regard the artistic and cultural life of that society as a barometer of its health. It is one of the main factors by which we assess a civilization. The cultural life of a society is that which defines it and gives it its uniqueness and identity. It is the hallmark of maturity. And the reason for this, of course, is that it is the arts that speak to the imagination and spirit in all of us. They enlighten, entertain, inform, educate and move us. And they lead us into a world unknown to previous perception.

Reading some of the press comment in recent days, however, you would have thought that the Government had forgotten all of this. Judging by our critics, we are a platoon of philistines prepared to boogie to Oasis and applaud *The Full Monty*, but totally uninterested in the work of the RSC or the fate of the British Museum. Well, I have news for those who might have thought this. We are not uninterested; we never have been uninterested; and we have no intention of being uninterested.

Max Hastings has recently written, 'Labour governments, and especially this Labour Government, are expected to show a sympathy for the arts, an instinctive sensitivity to the vital cause of seeing the largest number of people see the greatest possible number of films, plays, operas, great pictures and great museums.' Quite so. I could hardly have put it more eloquently myself. The thing that quite frankly baffles me is how on earth anyone ever developed the misguided idea that we might conceivably have abandoned such a basic tenet of faith.

And it is a tenet that does not just recognize the intrinsic importance of culture of itself. It also recognizes the importance of ensuring that the widest possible number of people can have access to that cultural excellence. If I had to encapsulate the central theme of our new Government's approach to the arts, it would be this: our aim is to make things of quality available to the many, not just the few. And I say 'things of quality' advisably, because we must not fall into the trap of assuming

that widening the audience for an artistic event or institution necessarily involves diluting the quality or excellence of the experience. It is important to have the twin goals of excellence *and* access in full view. The two go together; they do not – as some have assumed – contradict each other. It would be ludicrous to suggest that the fact that Channel 4 now broadcasts every Glyndebourne production means that the quality of the experience for those who go in person is somehow diminished. It would be equally ludicrous to suggest that, because the RSC takes its repertoire to Newcastle for a season, it is in some way 'dumbing down' what it does. Of course it is not. But it *is* making its magic accessible to people who would not otherwise get the chance.

Our commitment to access for the widest possible number of people has also led us to think seriously about the issue in relation to our greatest national museums and galleries. I read in some parts of the press that we are supposed to be on the verge of 'forcing' our museums to charge for entry. I can say here and now that I have no intention of taking such action. I will hope, however, to say something more about our ongoing work on this issue in a few days' time.[1]

Access and excellence are at the heart of what we want to achieve. But there is a further objective which sits alongside these: achieving a full recognition for the enormously important role that the arts and cultural activity in general play in our economic life. Creativity in its widest sense is at the heart of much of what we in this country are good at. It is the foundation of a new generation of high-tech, high-skills industries. Ideas are the building blocks of innovation, and innovation builds industries. This is *especially* true in a mature industrial economy such as ours. If Britain is to build new industries which fully exploit new technologies and capture new

1 In March 1998 I was delighted to be able to join the Chancellor of the Exchequer in announcing additional funding of £2 million from the Exchequer in order to secure continued free access for all to the National Gallery, National Portrait Gallery, Tate Gallery, British Museum and Wallace Collection.

markets, then we are going to need our share of creative, cultured individuals. Those who work in the traditional creative sector therefore have a lot to offer the business world.

The creative industries as a whole are big business. They are the fields in which jobs have been created and will be created, into the next century. And they all depend ultimately on the talent of an individual or the intellectual property that is created in order to succeed. That is why I welcome all moves to increase exchanges between the cultural and business worlds. It is also why we have established the Creative Industries Taskforce.

The role of the creative industries is an international as well as a national interest. We are fast approaching the UK Presidency of the European Union, and during the first six months of 1998 the UK will be at the forefront of the European stage. This will give us a real opportunity to highlight our national priorities. And it is fortunate that European minds – as well as our own – are turning to the importance of culture for our economic future. We will hope to use our Presidency to promote the creative industries in Europe. We want to 'make Europe work for the people'. And what better way is there of doing so than by showing the wealth of employment opportunities that are opening up in the cultural field? Through a number of events being specially planned for the Presidency, we aim to illustrate how culture benefits not just social life but also economic well-being and development. In May, for example, there will be a major international conference on the South Bank on 'Culture, Creativity and Employment'. And in April in Birmingham, we shall be hosting a major conference looking at the future of the audio-visual industries in Europe, setting the scene, I hope, for a new direction for European film and television into the next century. Many other concerts, exhibitions, festivals and conferences are already planned during the Presidency, and will illustrate how the arts can bring economic, employment *and* social benefits too.

Perhaps it has been inevitable that there has been some comment in recent weeks about the fact that the new

Government has not immediately announced an enormous increase in Exchequer funding for the arts. Would that I could have done so; but I cannot. As everyone must by now know, we said before the election that, for the first two years of this Parliament, we were going to adhere to the overall spending totals that had been laid down by the previous government. And we shall do so. The prudent husbanding of limited Exchequer resources must always be weighed against the desirable objectives we all seek to achieve. Getting that balance right is what the difficult business of government has to be all about.

But, simply because there can be no public-purse bonanza round the corner, it does not mean that doom and gloom and despondency have to spread through the artistic community. I say this for two reasons. The first is that we are currently taking a long, hard look at everything we do in the Department, at everything we fund and the structures that apply. Every department in Whitehall is doing the same, and I suspect that some radical and imaginative ideas will emerge from the process. I am very anxious, as part of this, to ensure that we get rid of unnecessary overlaps of bureaucratic procedure and make the most of every pound that is spent on the arts. I want to see money flowing into greater amounts of creative and cultural activity on the ground, rather than into the pockets of countless management consultants.

The second reason is simple, but crucially important. It is our intention to ensure that funds from the National Lottery can be devoted to the support of *people* and *activities*, and not just buildings. I cannot stress too strongly the significance of this change, and we are putting the necessary legislation through Parliament this winter and next spring, in the hope that it will reach the statute book by the summer. I can understand the initial reasons for doing so, but the Lottery from its outset has been hamstrung by the need to concentrate almost exclusively on bricks and mortar, rather than on what is going on inside the grand new temples we are building up and down the country.

Of course, after decades of neglect, the arts infrastructure needed to be attended to, and still does, but that does not mean that the emphasis should be so heavily on buildings. The various powers we are putting in place in our Lottery Bill – to enable the distributor boards to solicit applications; to place a duty on them to draw up strategies for the deployment of their funds; to establish a fast-track procedure for small grant applications of any kind; to allow channelling of funds through third-party bona fide bodies; and to insist on a shift from capital support to revenue support – will all help to achieve this. I want to see us taking a holistic approach to the quantum total of funding available for the arts, so that the Exchequer and the Lottery sit side by side and complement each other, instead of being regarded all the time as two completely antagonistic beasts. For years, after all, we were all saying what a difference it would make if there was a real leap in the funding available for the arts. Well, we have *had* a real leap, and it is called the Lottery. But the way in which it has had to be initially organized has meant that it simply has not been reaching all the areas that need it most desperately. Nor is this about replacing existing Exchequer support: the additionality principle must be pre-served. But the sensible use of Lottery funds can surely enhance mainstream Exchequer funding, to ensure that creative work can grow and develop, that excellence can be sustained, that access for all can become a realizable dream.

With the Exchequer and the Lottery playing more comple-mentary roles in future, we must not forget the enormous importance that will still remain for support from the private sector. Arts organizations derive their funding from a range of sources, starting, of course, with their audiences, at the box-office. Additional backing is and must be a partnership between private support and sponsorship, and public subsidy. That partnership is vital to sustain the excellence of companies that must perform at the highest level on the international stage. The RSC's relationship over an extended period with Allied Domecq is a prime example. I am happy to have the opportunity today

to pay tribute to the many other businesses, trusts and individuals who have similarly given their support, both large and small scale, to the great national companies and to nurture work at the grass-roots, in local communities.

The landscape of arts sponsorship has changed dramatically in the last twenty years. In 1976, when the Association for Business Sponsorship of the Arts (ABSA) was set up, business sponsorship for the arts stood at $£\frac{1}{2}$ million per year, with most support coming from major national and international companies. In 1996–7, however, some £95 million of business support was contributed to the arts throughout the UK, from companies of all shapes and sizes. My own Department's arts sponsorship initiative – the Pairing Scheme, which matches private-sector contributions with government funding – has contributed to this growth, bringing in over £125 million in new money to the arts since it began in 1984.

That success is heartening. But it may perhaps be time for a shift in emphasis. I know that Colin Tweedy of ABSA has already spoken about ABSA's vision for the future of arts and business links in Britain. ABSA's new focus on the ways in which the qualities inherent in the creative world can infuse and inform the *modus operandi* of all kinds of businesses is both exciting and very relevant to today's markets.

In the past, arts organizations have sought to benefit from the marketing and development skills of their counterparts from the business sphere. The growth of business sponsorship has not just brought in useful cash, but expertise and experience too. This is now changing – and rightly so – into a two-way process. It has become clear that we also need to look at the benefits the creative approaches of the arts can in turn bring to business. Increasingly, the qualities demanded for business – such as communication skills, flexibility of approach, improvisational and creative thinking, working as a team so that the parts add up to a whole – are precisely those that can be inculcated through exposure to the arts.

I believe that the cross-fertilization of talents and experience

between the two sectors, and the accompanying emphasis on staff development, is an area full of possibility for exploration. I am delighted therefore, that this conference is putting very much at the centre of its agenda the theme of what the arts can do for business, and not just what business can do for the arts.

The World is Your Oyster:
The Information Society and the Role
of Public Libraries

From a speech for the Public Library Authorities 17th Annual
Conference at the Palace Hotel, Torquay, on 23 September 1997

I am delighted to be here at this important gathering of those
who bear the responsibility for the nation's public-library
service. I know that Mark Fisher, the Arts Minister, participated
in last year's Public Library Authorities conference in Black-
pool. I hope that my presence today demonstrates that we take
our responsibilities for public libraries as seriously in govern-
ment as we did in opposition!

I would like to take this opportunity to set out the
Government's plans for the future of public libraries. Make no
mistake. They *do* have a future, and it is an exciting one. That
future remains true to the core principles that have underlined
the service for the past 150 years. But it will also require
everyone involved in libraries to ask searching questions and
make tough decisions about the nature of the service they
provide and the means by which it is delivered. Like any
organization, public libraries, and the people who run them,
adapt and respond to change or risk becoming marginalized
and peripheral to the needs of the communities they serve.

You have billed me to speak about the Government's plans
for the information society and the role of libraries. I intend to
approach this by turning your conference title on its head by
demonstrating the Government's intention that the world
should become *your* oyster. To do this, I would like to cover
four main areas: first, I would like to set out the context for this
Government's approach to the cultural sector as a whole;

second, I shall explain the Government's vision for the public-libraries sector and the role it plays as a platform for delivering wider cultural, social, educational and financial benefits; third, I would like to explain what we have done since coming to office to ensure that this vision is realized; and finally, I would like to look to the future and consider one of the most important issues facing the sector – how it responds to the challenge of harnessing information technology. I hope that, taken together, these strands will provide a clear picture of the Government's aims and aspirations for libraries – and of the opportunities that are now opening up.

Our vision for public libraries, and our strategy for maximizing the benefits to be obtained from them is intrinsically linked with our objectives for the cultural sector as a whole. I would therefore like to refer briefly to that wider picture before turning my attention to how libraries fit into the jigsaw.

Culture, of course, is a word whose definition can accommodate as little or as much as its user wants. Whatever your approach, culture in its widest sense is what gives us our sense of identity both as individuals and as a nation. But it is not simply about image and history. Culture also has a hard commercial edge. The creative industries are big business, and one of the Government's key objectives is to help improve economic performance in this area by taking a broad view of the cultural economy. This Government does not regard culture as marginal, or as an optional extra. It lies at the very heart of our mission.

How, then, do public libraries mesh with this? What part can they play in a national cultural renaissance? Public libraries are, quite simply, a corner-stone of our cultural life. They are both a stimulus to and a conduit for the creative industries. They are a central plank in the delivery of wider educational, social and economic benefits. They are accessible and egalitarian. They are a platform for self-development, a gateway to knowledge and a catalyst for the imagination. They are in a very real sense the people's universities. But, above all, they are highly respected

and used by the public. I can think of few other public services to which nearly 60 per cent of the nation's population subscribes. It is this bond with individual users and communities that represents the sector's single major strength, and long may this remain.

Libraries are hybrid organizations, offering a multi-faceted range of services to their members. Indeed, this very hybridity has in the past mitigated against the development of the library sector by placing it at one stage removed from other institutions – such as schools or colleges – with more formalized responsibilities. But libraries are very firmly on *our* agenda, and we view them in a very different way from our predecessors.

I am, however, conscious of the potential for conflict between the Government's desire to develop the library service as a platform for delivering wider policy objectives, and the vital principle of local determination that underlies public-library provision. I have a draconian power under Libraries legislation to direct an authority to take particular actions to improve the service it offers. For various reasons this has never been used, but my responsibility does require me to take an interest in the effectiveness of public libraries. I therefore need to establish a framework for the libraries sector which on the one hand influences what is funded and delivered locally, while recognizing on the other that the day-to-day running of public libraries will, quite rightly, remain a local matter. The way of squaring this particular circle is to develop an overall national strategy within which local library authorities can operate. This strategy must identify clear and achievable aims. It must ensure that the whole is greater than the sum of its parts. It must end some of the cross-divisions between central and local government. It must develop the links that exist between libraries and other sectors. And it must allow libraries to grasp the nettle in harnessing information technology. In short, it must ensure that libraries form part of the bedrock of the developing information society. I can assure you that this Government intends to help

with this so that we can get more from the national library network than we have in the past.

I would like, if I may, to illustrate this point with a couple of examples. The first concerns the social role of libraries. This Government recognizes that libraries have an important part to play in fostering community development and promoting community identity. What other service offers nearly 4,000 separate public-access points, spread reasonably evenly across the country, where entry is free, and where the environment is so welcoming and stimulating?

We therefore see library buildings not as mere bricks and mortar, but as focal points for communities. The public library is and will remain one of the best-developed and most accessible community resources. It provides an essential link between the needs of the local communities it serves, and the outside world. By providing community services such as homework clubs, by offering information on community history and identity, and by acting as a meeting place for community groups, public libraries can develop this significant role. Libraries are often the first point of contact between members of the community and their local authority, and are often the first local-authority service which children knowingly use. I would like libraries to develop that position and become the hub of community life. I would like them not just to be repositories for books and information, but actively to embrace their community by thinking of new and imaginative ways in which they can be used to this end.

My second example of this Government's new approach for libraries concerns the part they play in delivering educational benefits. You have heard it said many times, I imagine, that the Government has three main priorities – education, education and education. You will also hear, over the coming months, how we envisage libraries will contribute to that aim.

It is useful to remember that, when public libraries were first established in the middle of the last century, their primary purpose was seen as educational. This basic principle remains equally valid today, although of course the context in which

that service is delivered has changed dramatically, and libraries have developed new and different activities and functions alongside those concerned with education. Since the 1850s, public libraries have provided a largely free means of accessing, harnessing, sharing and developing knowledge. These services, sitting alongside the formal education system, enable people of all ages and abilities to participate in lifelong learning, and to develop their potential as enquiring, literate and informed human beings.

In its recent consultative paper on the National Lottery, the Government has recognized the support public libraries can give to formal education by ensuring that they can apply to the New Opportunities Fund in order to develop after-school clubs (see page 118). The Government's proposals for lifelong learning, and for the development of the IT-based National Grid for Learning, which will be published shortly, both embrace the public-library sector and recognize the valuable role it has in delivering educational benefits.[1] The path between my own Department in Trafalgar Square and the Department for Education and Employment in Great Smith Street is an increasingly well-trodden one. This has not always been the case in the past. We will be working very closely *together* in integrating public libraries, along with schools, colleges and universities, into a real learning network for the nation.

Public libraries also play a crucial role in promoting reading and supporting literacy, both of which are a fundamental part of an enlightened and civilized society. The acquisition, development and retention of reading skills are vital for the

1 The Government's proposals on lifelong learning and the National Grid for Learning were published by David Blunkett in *Connecting the Learning Society* on 7 October 1997. Substantial involvement for public libraries was included in those proposals, and further details of the Government's commitment to the development of information technology in public libraries have recently been published. This includes £20 million for the training of librarians; £50 million for the preparation of digitized material; and a continuation of the Wolfson challenge fund (see page 63) for local authorities to encourage new IT infrastructure.

intellectual and economic well-being of individuals and for society as a whole. Supporting literacy is one of the aspects of libraries which defines and identifies them. Libraries are in a unique position to offer parents, carers and others independent objective advice and guidance. They provide a motivation to read and a stimulus to continue to practise the skill.

Many of you will know of the valuable work conducted by Joanna Trollope and the panel of experts that was convened under the somewhat Stalinist title of the National Reading Initiative. Much of the panel's work focused on the numerous excellent schemes already run by many library authorities and looked at ways in which these could be developed in order to encourage more children to discover that reading can be fun. I am delighted to be able to tell you that many of the panel's recommendations will be taken forward under the umbrella of the National Year of Reading which the Education Secretary trailed in the recent Education White Paper. I am delighted to announce today that Joanna Trollope has agreed to serve on the steering group which is working up the proposals for particular events to run during the National Year of Reading. I am equally delighted that that group includes representatives from the Library Association itself, as well as those from the commercial sector, and that the sector as a whole will be playing a full part in ensuring that the National Year of Reading is a success. David Blunkett will shortly be setting out the details of what is proposed, and I do not want to steal his thunder by saying too much about the subject here. But rest assured that the plans are very exciting indeed.

During the four-and-a-half months since the general election, our strategic thinking and our long-term planning have also been backed up by a series of practical measures that provide a real benefit to the world of libraries.

First, we have given a fresh impetus to the development of annual library plans by library authorities. I referred earlier to my statutory responsibilities for the delivery of a comprehensive and efficient public-library service which I intend to fulfil

vigorously. Annual library plans are an integral part of this process because they will offer both library authorities and my Department a more rational and objective assessment of the level of service being provided by each library authority, and the ways in which it intends to develop that service in the future.

We have to date received more than 80 trial library plans from library authorities, together with more than 100 letters commenting on the developing planning process. The fact that so many have responded at length and in detail reassures me that the sector itself recognizes that annual library plans have an important role to play in improving the planning framework within which library services are delivered.

We have now finished the process of appraising the plans we have received and have prepared draft guidelines for use by library authorities on the content of future plans. Let me make it clear that I do not wish our guidelines to be *imposed* upon library authorities. If the process is to be of value, and to have meaning, there must be a shared responsibility for the values and principles espoused by the plans. For this reason each library authority will receive a copy of our draft guidelines within a week, and will be asked to comment on what is proposed. We will then reflect on the comments we receive, and distribute our final guidelines in November. I should mention that in developing our proposals we have worked alongside the Audit Commission whose *Value for Money* study on public libraries is published tomorrow. I will be responding formally to that report once I have had the opportunity to reflect a little more on its content. However, I was immediately struck by the links between what my Department is trying to achieve through annual library plans, and the sorts of strategic and operational issues identified by the Commission.

Second, we have taken some immediate measures to ensure that libraries can benefit from the National Lottery in the shape of the New Opportunities Fund. I have already mentioned the proposal which will allow libraries to develop after-schools clubs using Lottery funding. But there is a potentially more

significant commitment in the promise to provide funds to enable the training of up to 10,000 librarians in IT skills. That will help ensure that libraries have the human resources and skills required to deliver new services.

Third, we have confirmed our commitment to the new Partnership Fund established in conjunction with the Wolfson Foundation, which will, amongst other things, help public libraries to develop IT applications.[2] We are very grateful to the Wolfson Foundation for its contribution of £1 million towards this, which complements the £2 million we are providing this year. This week marks the closing date for applications, and I hope that we will be in a position to let bidders know of the outcome very shortly.

Fourthly, we have established new links with those in the libraries world who can help us to deliver our aims. I should acknowledge here the part played by the Library Association itself. We have enjoyed a number of fruitful discussions on issues of concern to the libraries sector generally. The Library Association has played a very helpful role in providing us with advice and in allowing a London-based Department to network more actively with the national public-libraries web. Our partnership with the Library Association will take a practical manifestation in November when together we celebrate National Libraries Week which Mark Fisher and I will be launching on 2 November at the House of Commons. Later in the Week both of us will take part in a number of events which are designed to demonstrate to the world at large the importance of libraries as a valuable and sometimes hidden national resource.

2 Through the generosity of the Wolfson Foundation, coupled with funding from government, we have been able to make available a challenge fund of £3 million in 1997–8, with now a further two years of similar funding from 1998–2000, in order to help local authorities carry out imaginative schemes in developing new information technology possibilities for their library users. The scheme has proved extremely successful, with many new projects now being undertaken and facilities created as a result.

Another manifestation of our commitment towards partnership can be found in the new relationship that is developing between the Department and its Advisory Council on Libraries. We intend to bring the Advisory Council and its specialist advice into the heart of the decision-making process. It is absurd not to listen to the views of a group with such widespread and deeply rooted knowledge of the sector. I am pleased to say that the Council has been fully involved, for example, in the development of our planning guidance for annual library plans. It is also playing a major role in the joint DCMS–Wolfson grant programme, and, together with the Library and Information Commission, is contributing valuable advice to a number of thoughts we are having about issues affecting the sector as a whole.

Having looked at what we are doing and why we are doing it, I would like now to turn to the future and say a few words on one of the single most important issues facing the public-libraries sector. How can the sector take advantage of the opportunities presented by the development of information technology?

You will all by now know that the Library and Information Commission was asked to report to the Government on this issue by the end of July. The Commission has moved heaven and earth to meet that deadline and I am pleased to be able to announce that the final version of the document will be publicly available, if all goes to plan, within the next three to four weeks.

The report the Commission has produced is *very* significant for the future of the libraries sector. The Government will seek to make an early response to the various recommendations it contains. I cannot say yet what that response will be. But I personally believe that the report represents a defining moment not just for public libraries, but for the sector as a whole. Without wishing to steal the Commission's thunder, I would like to offer you a preview of some of the report's conclusions.

The main argument is that the public libraries IT network strategy must involve more than simply bolting IT applications

on to the existing public-library system. It is about completely transforming libraries and what they do. It makes the case for re-equipping them, and re-skilling their staff, so that they become an integrated component of a new national education system – linked into the National Grid for Learning, partnering schools, facilitating homework clubs, supporting literacy acquisition, and helping children and students have access to and interaction with learning resources worldwide.

The report presents a compelling argument for libraries to be at the leading edge of technological change. It sees libraries as providing a bridge between the ordinary citizen and the wealth of knowledge and information available globally. It sees the library of the future as a catalyst for enabling people to involve themselves more fully with the democratic process, and to give them many more opportunities to participate in the decision-making procedures that affect their lives. It sees libraries as an enormously powerful agent for change, to be renewed and reinvigorated by investment in technology.

This vision is underpinned with a detailed and comprehensive implementation plan that takes a systematic and calculating look at what needs to be done in each of three main areas. Firstly, what sort of content should be delivered? Secondly, what are the training needs for the sector if it is to develop the skills-base necessary to deliver new services effectively? And thirdly, what sort of physical infrastructure is needed in order to deliver a comprehensive national public libraries IT network? Equally importantly, the report also identifies the likely levels of investment that may be required, and examines various funding models designed to ensure that that investment will be made. It effectively throws down the gauntlet not only to government, but to the libraries world and our technology and communication industries, to seize the moment and redefine the very nature of the public-library service.

I trust that you will forgive me for using this opportunity to roam over such a wide range of issues. The essence of the public-libraries sector is such that it is difficult to do otherwise. I

wanted to conclude this speech with a single image which encapsulates what we are trying to achieve. I was struggling with this until once again, the Library and Information Commission's draft report came to my rescue.

The report contains a poem which I find immensely moving. It is by Ted Hughes, who had been persuaded to write a special poem about libraries as an introduction. I can find no better summation of what we are all trying to do, than to quote from the last quatrain:

> Even the most misfitting child
> Who's chanced upon the library's worth,
> Sits with the genius of the Earth
> And turns the key to the whole world.

Past Present:
The Importance of World Heritage

A speech for a Conference on World Heritage at the Queen
Elizabeth II Conference Centre, London, on 21 October 1997

We are here today to celebrate twenty-five years of the World Heritage Convention, the establishment of which was a milestone in the way we think and act about the most significant places on earth.

Whether they are natural sites, or reflect in some important way man's cultural development through the ages, they are invariably special, numinous places. They encompass the grandeur of creation or the skill of humankind – sometimes both together. The Grand Canyon in America, the Pyramids in Egypt, the Great Wall of China and Stonehenge – to name a few obvious examples – can evoke real wonder. World Heritage Sites are by definition of outstanding universal value. They are places, perhaps more than any other on this planet, that each generation should hold in trust for those that follow. And our treatment of these sites – the love, respect and protection we give them – itself provides a measure of our progress and development and helps both to explain and define what the word 'civilization' means.

Nowadays, with the explosion of international tourism, the speed of travel and communications, the thirst for instant news from around the globe – and its ready availability – the world is truly a small place. That much is a modern truism. But surely the very compression of our world view has made all the more crucial E. M. Foster's injunction: 'Only connect.' What was true for Margaret and Helen Schlegel is true also for all individuals

and applies equally to nations. In 1997, there are very few areas of life which do not embrace an international dimension, and this interrelatedness leads inexorably to a sense of shared international responsibilities. This is as applicable to the heritage sphere as to any other.

The best examples of each country's cultural and natural heritage are of course invaluable national treasures. But they can no longer be looked upon as just that. The Tower of London, Hadrian's Wall and Canterbury Cathedral, for example, are each in their own way remarkable and magnificent structures. But it is easy to fall into the trap of perceiving them only in those terms. In fact they owe their existence and their significance to developments in the much wider contexts of European military and spiritual history and the interaction of nations and ideas.

During the last few weeks, as we have contemplated the unfolding tragedy of the earthquakes in Umbria in central Italy, we have been forcefully reminded of our shared interest in, and concern for, heritage sites of global importance. We have been reminded, too, that it is not only the 'star' sites that matter – the upper and lower basilicas in Assisi – but the great network of buildings and churches and frescos and hill towns that stretches from Bevagna and Montefalco to Federico's ducal palace at Urbino. Unesco must of course stand ready to discuss with the Italian government what now needs to be done.

One other point, incidentally, is borne home to us by what has happened in Umbria. It seems likely that the greatest damage has occurred where the most inappropriate and officious attempts have been made in the past to preserve the very heritage that has now gone. The installation of concrete supports some thirty years ago has created rigid structures that cannot 'give' with the movement of the ground. Efforts to preserve in the wrong way can end up lending a hand in the destruction. It is a lesson we can all learn from.

So it is wider currents than just the national that have shaped and determined human history. This seems obvious to us now

and to the phalanxes of international tourists who criss-cross the globe each year on the world heritage trail. But back in 1972, the need to identify and protect the best of the natural environment, and manifestations of human cultural and spiritual development, was not such an obvious truth as it is today. And it is a mark of Unesco's prescience and innovative thinking that it recognized and codified the holistic concept of world heritage so long ago. Unesco saw the need to engender a common, universal responsibility to preserve and protect this inheritance for future generations – an inheritance that could help us understand more clearly what it means to be human. This was an ambitious task. It was an idea that caught and fired the imagination then and continues to do so now.

Why are these pieces of nature and created artefacts from the past so important? Partly, I think, because they remind us all of something bigger and greater than ourselves. They are epiphanies – of the process of natural creation, perhaps; or of the tide of human history and tradition; or of all that multifarious web of circumstances and chances and decisions that has made today the thing it is, a child of what went before.

Heritage sites and buildings are not just important because of what they reveal about the past, however. Nor are they just fine parts of a human-created landscape that are pleasing to the eye and interesting to the intellect. They are examples that we carry with us into the future. We can learn from them, we can teach from them, we can inform our future choices by understanding them. In a very real sense, heritage is as much about the future as it is about the past.

The World Heritage Convention came about because, in the late 1960s and early 1970s, many extremely important natural sites were under threat and desperately in need of greater protection and care than the countries concerned were either willing or able to provide. The threat to the great monuments in Nubia following the construction of the Aswan High Dam increased worldwide support for Unesco's initiative to establish some kind of mechanism to focus international action.

Unesco's 1972 World Heritage Convention set out to identify those cultural and natural properties and sites in each country whose protection would warrant exceptional international efforts to save them from damage or destruction. These sites are described in the Convention as places of 'outstanding universal value from the point of view of art, history, science or natural beauty'. A necessary concomitant to this process was to make the sites more widely known and respected. The Convention has now been ratified by 147 states, and there are currently 506 World Heritage Sites spread over 107 countries. Inscription as a World Heritage Site is perhaps the highest accolade a place can receive and brings with it enormous international prestige.

The type of problem addressed under the Convention can be illustrated by the case of the Butrint World Heritage Site in the extreme south of Albania – an area of the greatest archaeological and historical importance. Following the civil unrest in the country earlier this year, this site was severely damaged by looting, which included a raid on the museum located in a restored Venetian castle on the Butrint acropolis. Unesco and the International Council on Monuments and Sites (ICOMOS) are sending a mission to Butrint to provide a first-hand report of the conditions and assess the need for international assistance.

Despite the UK's withdrawal from Unesco in 1985, I am glad to say that we remained parties to the World Heritage Convention over the intervening period and contributed annually to the World Heritage Fund. This Government took the significant step of rejoining Unesco as full members very shortly after we assumed office – on 1 July to be exact. This will enable this country not only to play a much fuller part in world affairs across a wide range of educational and cultural activities, but also to strengthen its voice internationally on heritage matters – a sphere in which our expertise is second to none.

The UK, which ratified the Convention in 1984, currently has sixteen World Heritage Sites, of which ten are in England, two in Scotland, one in each of Wales and Northern Ireland, and

two in overseas dependent territories: Gough Island in the South Atlantic and Henderson Island in the Pacific. In addition, we are currently awaiting the World Heritage Committee's decision, due in December, on the nomination of Maritime Greenwich.[1]

The variety of these World Heritage Sites is impressive for these relatively small islands. They range from sites of natural beauty, such as St Kilda and the Giant's Causeway, to sites of supreme historical or archaeological interest, such as Durham Cathedral and Stonehenge. But there is room for more.

Over the last ten years or so, only three new nominations have gone forward to Unesco: Edinburgh's Old and New Towns, Gough Island and Maritime Greenwich. Furthermore, the 'tentative list' of possible new nominations has not been amended over that period. It is high time the list was updated and I intend to do just that. In collaboration with my colleagues in Scotland, Wales and Northern Ireland, arrangements are now in hand to set up a group of experts to help the Government draw up a new tentative list of sites in the UK and its dependent territories that could be nominated to Unesco for World Heritage status over the next ten years. The group will include representatives of English Heritage, the UK arm of ICOMOS, the Countryside Commission and other relevant bodies.

What types of site will be covered by the new list? Well, the UK has had a huge and varied influence on the world's evolution over the centuries. We have led the world in industrialization, for example. And I believe that our *natural* sites are not as well represented as they might be. In these and other ways, I feel the World Heritage list should better reflect our heritage.

But, above all, our approach must be realistic. Unesco's criteria for inscription are extremely stringent. In view of the great amount of work that has to go into the preparation of

1 Since this speech was delivered, Maritime Greenwich has in fact been designated as a World Heritage Site, and a management plan agreed.

nominations, I would only want to include those sites in the new tentative list that stood a real chance of being accepted by the World Heritage Committee in the longer term. I know that a very large number of UK sites have been suggested for nomination over the years. Therefore, selecting the final list will not be easy, and the working group will clearly have to make some hard and difficult choices when making its recommendations to me.

I have already mentioned ICOMOS, the body which advises Unesco's World Heritage Committee on the eligibility of sites for World Heritage status. I am pleased to say that, exceptionally, my own Department provides some financial support for the UK arm of ICOMOS. In recent years this has covered, among other things, the production of a ground-breaking monitoring report on all the English sites, which was a first of its kind internationally. And its day-to-day work in fostering and encouraging the development of management plans, in co-operation with English Heritage, local authorities and others, is also vital.

Another body which has made great progress in this sphere is the Local Authority World Heritage Site Forum. I was very pleased to attend the Forum's inaugural meeting at Ironbridge on 5 April 1995, when I was the Shadow Heritage Secretary. The credit goes to Wrekin District Council, and to Councillor Philip Davies in particular, who took the initiative to set up the Forum, which comprises representatives from each of the local authorities with an interest in a World Heritage Site, as well as the UK arm of ICOMOS and my Department.

The Forum seems to me to be providing an invaluable mechanism for the discussion of a large range of issues relating to the effective management of UK World Heritage Sites, and local authorities' interests in them. Its existence also highlights the importance of democratic accountability in a field in which it is easy for specialists and agencies to become the dominant players. Indeed, some thirty-three local authorities have World Heritage Sites partly or wholly within their areas, and many key

tasks of management and site protection fall to them – not least the need to incorporate appropriate protective policies for sites in their local development plans. Many of the management issues relating to World Heritage Sites are common, and local authorities can learn a great deal from the exchange of knowledge and experience. The Forum provides the mechanism for this. The aim to 'think globally and act locally' is a goal particularly apt for the Forum – and, indeed, for everyone with responsibilities in this area. Managing the small-scale detail well is a key to shouldering the globally important task of conserving the whole.

I mentioned the establishment of management plans. This is crucially important work. It is simply not enough to inscribe sites. We must make sure that they are cared for in a way that is worthy of their significance and value. Indeed, Unesco now requires that all future nominations for World Heritage status should be accompanied by worked-up management plans.

Experience has shown that the development of such plans is a resource-intensive and time-consuming activity. And of course there is a continuing commitment to ensure that the policies and objectives of the plan are realized over time. So it is important that anyone suggesting the nomination of a site should be fully aware of what is involved. This means that, before any future nominations are made, we shall need to consult with interested local concerns to ensure their full support.

So far only one management plan is in operation – that for Hardian's Wall. But I am pleased to say that, with the help in particular of the UK arm of ICOMOS and English Heritage, substantial progress has been made towards the development of plans for many of the other UK sites. For example, at Ironbridge a framework document has recently been circulated to all residents and businesses within the site, setting out the principles underlying the proposed management plan as well as the priorities for action. A first draft of a plan for Avebury is likely to be available early next year, and this work will shortly be extended to embrace the Stonehenge part of the World

Heritage Site. I should also mention that, in advance of the decision on inscription, much effort is currently being expended on the production of a management plan for Maritime Greenwich, where the London Borough Council of Greenwich is taking the lead.

Over the next year my Department, in co-operation with the other agencies concerned, hopes to make substantial progress on these plans and encourage the development of others. But the process is by no means an easy one, and there are many difficult issues to address. Of all the UK's World Heritage Sites, Stonehenge is perhaps the most problematic and headline-catching. It certainly is the one that most threatens to keep me awake at night. Despite twentieth-century clutter which surrounds it, Stonehenge remains a fascinating, mysterious and awe-inspiring place. For a number of reasons, the image of Stonehenge is very firmly embedded in, and important to, the national psyche. Without doubt it is among the most well-known symbols or icons of Britain lodged in the world's consciousness. It is of course England's most important prehistoric monument and, arguably, the most remarkable prehistoric monument in Europe. It is also the country's most visited ancient monument, attracting some 700,000–800,000 visitors a year. And it is set in the most significant Neolithic and Bronze Age landscape in England.

And yet . . . and yet. Despite the incredible importance of this monument, we have so far failed as a nation to find an acceptable way of presenting it. The existing car-park and those shabby, temporary huts we all know and hate detract from the dignity of the Stones and disfigure the area. The tunnel lined with lavatory tiles is hardly the best induction to the mystery of the monument. And of course the two roads, one of them a major highway, cut off Stonehenge from its landscape. Indeed, one of them – the A344 – passes within a few yards of the Stones. It is a dreadful situation. So what can be done?

Well, it is fair to say that there have been numerous attempts to find a solution. But, as anyone familiar with the site will

know, there is a long, difficult and rather depressing history of not securing sufficient consensus, because the problems are so complex and there are so many players and interests involved. English Heritage, which manages the site on the Government's behalf, has the vision of ultimately removing all vestiges of twentieth-century man from the vicinity of the Stones and returning the landscape to its original appearance of open chalk downland. What a magnificent achievement that would be!

In pursuit of this, English Heritage has produced a number of improvement schemes over the years, but none has come to fruition. Its recent proposal to build a new visitor centre – first at the Countess Farm site, and then at Larkhill, pursued in partnership with the Tussauds Group under the Private Finance Initiative – was abandoned earlier this year after the Millennium Commission refused a grant.

To his great credit, the chairman of English Heritage, Jocelyn Stevens, who I know is personally committed to improving Stonehenge's presentation, remained undaunted by this setback. He has continued energetically to explore all the options, including the extent to which use of a site at Larkhill might offer a solution. The possibility of locating new and small-scale visitor facilities at Larkhill has come forward on a number of occasions in recent years and certainly merits further consideration. The advantage of Larkhill as a stepping-off point for the Stonehenge landscape is that it does present the most marvellous view of the Stones rising against the horizon. and it is not so far away that visitors would be deterred from walking through the landscape to reach them. Moreover, the existing byway provides a means of channelling them through this sensitive area.

However, in all the discussions that have been held over the years about the need to remove the twentieth-century detritus from the immediate vicinity of the Stones, there has always been a problem in looking to the north because of the security issues surrounding the Ministry of Defence's garrison at Larkhill. I am therefore pleased to be able to say that, following detailed

discussions, the MOD has raised no overriding objections on security grounds to the possible access route to Larkhill which English Heritage has been considering from the northeast of the site. The MOD has said it is prepared to make the necessary land available for the road, which would start from a point a short distance along the Packway, avoiding the need to channel any traffic through the Larkhill garrison and minimizing the impact on the houses in which members of the garrison live. The land that would be affected by the proposed new road has minimal archaeological importance.

This agreement with the MOD opens up possibilities for using Larkhill that were not previously available. But other solutions have been suggested which also deserve consideration. Neither my Department nor English Heritage would wish to proceed further without additional discussions with the local community. To this end I intend to go to Stonehenge myself as early as possible in November to meet the local authorities and other interested parties to hear their views on the various options for taking forward the management of this magnificent World Heritage Site.[2]

I have stressed the international value and significance of the UK's World Heritage Sites. We should not forget, however, their great *national* importance, not only intrinsically but also as the apogee of a much wider heritage in the UK. The environment in which we grow up – both the natural historic landscape and our human surroundings – is crucially important in establishing a sense of who we are as individuals and as a nation. Historic buildings and historic environments represent a finite resource and an irreplaceable record which contributes through research, through formal education and, perhaps most importantly,

2 Since this speech was delivered, I have been able to visit Stonehenge twice to talk to local residents and representatives and other interested parties; and an alternative approach to the Stones, coming from the west, has been identified as perhaps the best way forward. I am very pleased that a general consensus appears to be emerging at last about the need – and the realistic possibility – of transforming the way in which the Stones are kept and presented.

through our daily experience, to our understanding of the past – and therefore of the present.

We think we in Britain have a long and proud tradition of statutory protection and preservation. But in fact it is largely a late-Victorian phenomenon beginning here in the 1870s. Even at the time of the first legislation to protect ancient monuments in 1882, there was opposition. Lord Francis Hervey asked why we should retain anything from our barbarous past and refused to recognize our ancestors.

I am glad to say that Lord Francis Hervey's prejudices did not prevail. Nowadays there is consistent and widespread support for the view that historic buildings and areas must be valued and protected for their own sake, as a central part of the cultural heritage and for the contribution they make to our nation's sense of who and what we are. Many people derive deep and lasting pleasure from living and working in historic buildings and areas, visiting them, studying them in depth or simply having them there in the background. In short, the historic environment adds immeasurably to the quality of our lives.

The preservation and enhancement of historic buildings can also promote confidence in the future of an area and act as a catalyst and focus for regeneration. An attractive historic environment of definite character can draw in investment, encourage sustainable development and help maintain not only a sense of community, but also a community in touch with its roots.

More tangibly, perhaps, historic environments can contribute greatly to the nation's prosperity through tourism. Visitor surveys have shown that over 80 per cent of overseas tourists cite heritage and countryside as important factors in their decisions to come here. Our World Heritage Sites are major attractions, as the statistics demonstrate. Each year Westminster Abbey receives some 2.5 million visitors, Canterbury Cathedral 1.7 million, the Roman Baths and Pump Room in Bath 900,000, Stonehenge 750,000, and the annual visitor numbers

for Durham Cathedral and Blenheim Palace are 500,000 and 420,00 respectively.

Indeed, tourism is forecast to be the world's biggest industry by the millennium. This is very good news for the UK because we earned some £12 billion from overseas visitors last year in an industry which is currently worth £40 billion and represents 5 per cent of the GDP. Nearly 2 million people are employed in tourism and hospitality in this country.

But with the benefits come challenges. The popularity of our World Heritage Sites means that they need careful management. There is a palpable tension between the need to encourage tourism as a growing industry and the need to ensure that the best, and often the most fragile, aspects of our historic cities and sites are not irrevocably eroded or otherwise spoilt by the sheer numbers of tourists. Access must be weighed against protection and long-term sustainability – an issue which I know greatly concerns ICOMOS. Clearly the long-term protection and conservation of our World Heritage Sites must be our overriding objective. How to achieve the right balance in practice is the essence of the management-plan process. And sustainability – both for the natural and the human-created environment – must be at its very heart. We must not trample our heritage to death, nor must we render it completely inaccessible. The proper balance between access and nurturing must always be sought.

I have emphasized today the importance this Government attaches to the built and natural heritage – not just World Heritage Sites but the heritage that forms the colourful backcloth to our daily lives. Of course, the Government can only do so much. It can set the legislative and policy framework for successful conservation and, wherever possible, it can offer help, encouragement and even perhaps some resources. But the successful management of World Heritage Sites, and indeed of the heritage generally, must depend also on local action – the activities of owners, local authorities and other interested bodies. The continued co-operation, help and commitment of

these parties is essential if we are to manage our heritage effectively.

I have always been struck by the power of word and thought in the closing chorus of the Women of Canterbury at the end of T. S. Eliot's *Murder in the Cathedral*. Very succinctly they remind us of what this 'heritage' concept is all about. And how appropriate it is that they speak it, primarily, about Canterbury – one of our own World Heritage Sites.

For the blood of Thy martyrs and saints
Shall enrich the earth, shall create the holy places.
For wherever a saint has dwelt, wherever a martyr has given
 his blood for the blood of Christ,
There is holy ground, and the sanctity shall not depart from it
Though armies trample over it, though sightseers come with
 guide-books looking over it;
From where the western seas gnaw at the coast of Iona,
To the death in the desert, the prayer in forgotten places by
 the broken imperial column,
From such ground springs that which forever renews the
 earth
Though it is forever denied. Therefore, O God, we thank
 Thee
Who hast given such blessing to Canterbury.

In a Great Tradition:
The British Music Industry

From a speech to the Recording Industry Association of America at the Sony Club, New York, on 22 October 1997

It is very fitting that I should be giving this speech in New York. It was here, after all, that many fleeing from slavery, and many refugees from Europe, especially Eastern Europe, got their first taste of freedom. One cannot over-emphasize the contribution of black and Jewish composers and performers to the development and popularizing of music, especially modern music of all types. This is, incidentally, a lesson we are beginning to learn in Britain many decades later.

My main message tonight is very simple: I believe that the US and the British music businesses, though competitors to some extent, have a great many interests in common. As a new government, we want to build on our strengths, and that means fostering an approach of partnership between you and us.

British and American music are particularly close because of our common traditions. American folk music draws much inspiration from the folk music of England, Scotland, Ireland and Wales. When Cecil Sharp was collecting folk music, he often found English songs, or variants, which had been preserved only in the Appalachians. Paul Simon and Bob Dylan were two young American singer-songwriters living and working in Britain in the early 1960s who performed in folk clubs and reflected British folk traditions in their music.

Returning the compliment, the melting pot of American folk music, which gave the world jazz, rock and roll, country and western and a mass of other genres, influenced popular British

music which, in turn, has affected American music. Bob Dylan, American R&B bands or blues artists like Muddy Waters, affected the Beatles, the Rolling Stones and Cream. British artists in turn influenced the Beach Boys and the Byrds. The Rolling Stones used rhythm and blues themes in developing their own distinctive style and were paid the ultimate compliment when US soul legend Otis Redding recorded the Jagger/Richard classic composition 'Satisfaction'. Punk rock started as an underground movement in this city, spearheaded by groups like the New York Dolls; their manager Malcolm McLaren brought both the music and fashion back to Britain and went on to manage the Sex Pistols who, together with other leading British punk bands such as the Clash, influenced American bands like Guns 'n' Roses. Reggae was pioneered in the Caribbean, popularized in Britain, and developed into rap in the United States. Perhaps we can say that the British typically add a dash of irony before re-exporting music to the USA. What is undoubtedly true is that the British and American traditions in music are thoroughly and intricately intertwined.

Just as it is sometimes difficult to remember, or even tell, whether a pop star or group is British or American, so the value chain - from performer to record production - seems to straddle the Atlantic. Bush are big in America, and signed to an American company; UK groups like Pink Floyd and the Rolling Stones were top touring bands in the USA. Tina Turner is signed in Britain. Between us, the US and the UK have by far the greatest share of the world market for recorded music. Sales of recordings by British and American artists together account for over 50 per cent of records sold worldwide.

The British music business is one of our most valuable creative industries. Annually it is worth $4 billion to the UK economy, including around $2 billion generated overseas. The industry employs 115,000 people. Its net export earnings are bigger than those of our steel industry, and our musicians' union is now bigger than our miners' union.

The business is high risk. On average, 80–90 per cent of

artists signed to record companies will not succeed. But, for those who do, the rewards are enormous: for the artists themselves, for the record companies who sign them, and for the songwriters whose works are recorded by the artists. The British music business itself invests heavily in new talent. Most record companies based in Britain reinvest 13 per cent of their annual turnover in signing and developing new artists – an A and R percentage that is among the highest in the world. This is no accident: we have a tradition of musical innovation, development of genres and a broadcasting environment which encourages iconoclasts, without harming commercial strengths.

Britain is a hothouse. Although the UK represents only about 7 per cent of the total world market for sound recordings, around 25 per cent of all records sold worldwide have a British element – be it artist, songwriter or record company. UK artists currently enjoying significant success in the US include not only the ubiquitous Spice Girls, but Seal, Enya (Irish, but signed to a UK company), Oasis, the Prodigy, Jamiroquai and UB40, all of whom have joined consistently popular artists such as Phil Collins and Elton John in selling many millions of records in the United States. Of course US artists, such as Mariah Carey, REM, Whitney Houston and many more, have in turn enjoyed spectacular popularity in the UK.

The new British Government wants to do all it can to create the right environment for the music business to flourish, to benefit all those involved, from performers right through to recording companies, exporters and distributors. That is why we have moved responsibility for the music industry to centre-stage in my own Department. And it is why we are turning our attention first and foremost to the need to protect intellectual property rights, the fundamental building block of musical success.

UK creative industries already benefit from strong copyright laws, strongly enforced, which give companies strong incentives to invest in the business, knowing they can achieve a proper return on that investment. In many countries of the world,

however, copyright laws do not give adequate protection to creators. In many more, the laws are in place but protection is woefully inadequate. And in some, sadly, there is open flouting of international agreements. The US government has been very active in promoting the enactment and enforcement of adequate copyright legislation outside the US, and we want to work together with you to keep this issue high on the international agenda.

As we move into the global information society, it will be important to ensure that laws keep pace with technology. Investors must have the same opportunity to obtain a fair return when they sell recordings electronically as they currently do when CDs are sold in shops. As part of this process, it will be important for all signatories to the recent World Intellectual Property Organization treaties to ratify these agreements as soon as possible. I am determined to seize the first legislative opportunity I can to ensure that Britain ratifies.

There are increasingly difficult issues, of course, in relation to access through the Internet to cyberspace collections of musical material. This is a problem that only international action can address, and even then we are unlikely to achieve 100 per cent coverage with ease. It may be that technology will come to our aid, with the development of 'digital signature' mechanisms to track original material. What I do know, however, is that we certainly cannot ignore this issue, or wish it would go away. We have to strive for the right international framework of law.

Increasingly, many people are seeing investment opportunities in British music. You may have read recently about the Bowie Bonds issued by Wall Street-based Nomura Securities, which enabled David Bowie to raise $55 million through their sale to Prudential Insurance. The bonds were guaranteed by the steady flow of royalty income David Bowie's songs and recordings still generate. Other top British artists rumoured to be looking at similar deals include the Rolling Stones.

British music is moving fast, and rewarding investors. As I mentioned earlier, public service broadcasting on the BBC's

Radio 1 helps. Above all, it provides a service which embraces all types of popular music genres and does not have to satisfy only the market. It is joined by a number of imaginative – and increasingly independent-minded – commercial stations. Radio, for years, has played music outside peak hours to audiences interested in new and pioneering genres. It is the critical component in creating a virtuous circle, unique to Britain, which allows new acts access to the airwaves, attracts the attention of A and R people, and then develops some of them into commercially successful acts. This has allowed a huge growth of genres almost unknown in the USA: for example, ambient, dub, dance, drum and base. The Prodigy, Massive Attack and Roni Size are at the cutting edge of new musical forms. Our broadcasting therefore allows for risk-taking and innovation. We have a complex home market which is under-exploited, and there is much for A and R funding to find and develop, coupled with our plans for a National Endowment to support talent and our new emphasis on music in schools. This is why we deserve, and will repay, investment, and why I say to you tonight: thank you and please continue; and to those not yet doing so, I say: take a look and take a few risks. You will not be disappointed.

Making Movies:
The State of the UK Film Industry

A speech for the British consul general's reception in Los Angeles on
24 October 1997

Although I am well aware of the massive contribution that
companies in Los Angeles, and indeed along the whole West
Coast of America, make to so many of the creative fields,
including music, television and the new technologies, I would
like to focus this evening on the industry that is synonymous
with this city – the movies.

Like Hollywood, Britain can boast a fine tradition of film-
making throughout the hundred-year history of the commercial
cinema. And we have always worked well in partnership with
the Americans. Some of our greatest names have been snapped
up by your studios to bring their unique talents to the
Hollywood dream factory. From stars of the silent era and
early talkies, like Charlie Chaplin and Stan Laurel, through
such masters as Hitchcock and Olivier, to our current 'A-list'
names, like Sean Connery, Gary Oldman and Alan Parker, Brits
have come to Hollywood in search of fame and fortune. I am
delighted too that, in Ewan McGregor, we now have a star who
is so big that he did not have to come to the States to make the
latest *Star Wars* film, but ensured that the whole production
was brought over to the UK!

More seriously, the decision of George Lucas to bring his *Star
Wars* production to our new studio at Leavesden is indicative of
the fundamental good health of the British film industry. In
addition to our great acting and directing talent, we have some of
the best technicians and craftspeople in world cinema, and we

also have a growing band of young, ambitious, commercially focused producers who want to make films for the widest possible audiences. Recent successes like *Bean*, which has already taken more than $100 million worldwide even though it has yet to open in the United States, and *The Full Monty*, a film which cost less than $5 million to make but which has been the top film in Britain for six weeks and has already taken over $50 million worldwide, are evidence of this most welcome trend.[1]

As a result of these hits and the improved financial climate, there is now a tangible sense of optimism in an industry in Britain which, according to many commentators, was dead and buried ten years ago when cinema admissions had dropped to around 50 million annually and the number of films produced fell to just 30 in one year. Last year more than 120 million cinema tickets were sold in British cinemas and there were 127 productions. This is not much compared to the statistics for the United States, I know, but it is concrete evidence of a rapidly expanding market in the UK.

This consistent run of popular movies is something new for us in Britain. In the past we have had brilliant successes: a Merchant Ivory film, perhaps, or a *Chariots of Fire*. But they have come and then gone again. The long run is new, and I certainly hope it will stay that way.

One of the reasons for this change is that we have recognized a very simple fact about movie-making: that it is *both* a cultural and an economic activity. There has been an arcane debate among some of our European colleagues in years gone by about the theology of what film is. Is it cultural product, to be protected and defended, or is it economic opportunity, to face the brisk winds of commercial activity around the world? The answer, of course, is that it is both; and if you make good movies you will have successful movies. I believe we are demonstrating the truth of this dictum at this very moment.

1 Since this speech was delivered, *The Full Monty* has become the highest-earning British film of all time, with a total figure of £140 million and still rising. It has also, of course, won an Oscar for best original score.

Immediately after being appointed Labour's Secretary for Culture in May, I went to Cannes to announce my seven point plan for helping the film sector to develop from a series of small craft businesses into a properly integrated modern industry. Our strategy, therefore, is to look at all aspects of the industry, including distribution and exhibition as well as production, in the context of Britain's unique position as a bridge, geographically, culturally and economically, between Europe and the United States.

The first part of that plan had already been implemented two days after the general election, when Tony Blair invited Tom Clarke to become Britain's first ever officially designated Films Minister. Point two was to address skills shortages by ensuring that the Government's wider strategy for getting young people out of the dole queue and into work through a targeted programme of placements and training to recognized standards – the Welfare to Work initiative – was fully implemented in the film sector. Without training and the development of skills, of course, it is useless stimulating investment in production: you simply inflate the price of talent. A growing pool of talent to make a growing number of movies is what we need.

Thirdly, I pledged that the Government would address the financial and fiscal arrangements for film-making in the UK to encourage greater investment in the industry. In May, I announced the winners of the three franchises which will have access to over £90 million of National Lottery funds over six years to make films with a total value of around £460 million (and that does not just mean making two or three *Titanic*s – the franchises have plans to make around 90 small- to medium-budget films). In July, eight weeks after we had taken office, the Chancellor of the Exchequer, Gordon Brown, introduced 100 per cent tax relief for film production costs, granting the industry an incentive for which it had campaigned for years.

I have already mentioned that in the last ten years cinema attendances in Britain have more than doubled. My fourth point, and the real challenge, is to ensure that British films

achieve a reasonable share of that increased cinema audience. I have set the specific target of doubling the market share enjoyed by British films at home. Historically, and despite producing some excellent, critically acclaimed films, we have struggled to take as much as 10 per cent of our own box-office. Thanks to the performance of some of the films to which I have already referred, we have improved on that figure this year. Now we must make sure that this is not just a blip and can be sustained and improved on throughout this year and beyond. We have the product to justify a far greater market share: *Mrs Brown* and *Wilde* are just two examples of recently released films which I hope will continue this trend. But, if we are to sustain it, we need to develop healthy and constructive relationships with the people who dominate the distribution and exhibition systems in the UK. I believe we have a common commercial interest in seeing this market share improve.

I am also concerned about the narrowing of the cinema audience in Britain, the great majority of whom are aged under twenty-five. The fifth point of my plan, therefore, is to reach out to those former cinema devotees who have stopped going to the pictures for one reason or another and encourage them to come back. One way to do that, I believe, is to offer more and better films, including those reflecting British themes, in more and better cinemas. The major cinema chains, including many American companies, have had the foresight and confidence to make major investments in new multiplexes and refurbishment of old cinemas so that going to the cinema is now a far more pleasurable experience in the UK than it was in the 1980s. In carrying out such improvements, the chains have shown that providing a good environment in which to watch films is just as important as providing good films to watch. The idea that movie-going offers 'a good night out' is catching on again, and I hope it does so increasingly for a broader audience. The UK is still desperately under-screened compared to the USA and most of Europe, so the development of more screens and complexes is something that I want to encourage. The new multi-screen

transformation planned by Warner and others for the old Battersea Power Station on the banks of the Thames in London is one particularly exciting development.

The sixth area I am examining is exports. Many of the best British films and TV programmes deserve to be seen more widely internationally. The great worldwide success of *Bean* and *The Full Monty* shows that this is possible, but they are still exceptions to the general rule that British films tend to achieve limited results within their own market and poor returns elsewhere.

Finally, my seventh point – one of particular relevance to my trip to the United States – is to look at how we can assist the work of the British Film Commission and our network of regional film commissions to attract inward film and television investment into the UK. US companies have recognized the advantages of filming in the UK and I hope that these have already been improved by the fiscal incentives that I mentioned earlier. There are many more *Braveheart*, *Mission Impossible* and *Star Wars* movies out there – and the new climate will, I hope, encourage the *whole* of such films to be made in Britain in future. I want to work with the film commissions to ensure that film-making in the UK remains a pleasurable and profitable experience for overseas companies.

Many of you here this evening know the varied bonuses Britain can add to film production - the quality of production crews, post-production facilities, SFX, and the stunning diversity of locations with good facilities and services to match. To that enticing menu we can now add yet another item: music. The growing importance of movie soundtracks, both as a selling point and merchandizing spin-off from films, is unmistakable. British bands and musicians are more and more a feature of the most successful feature releases, including films made by US, Australian and European film-makers.

These seven points add up to an ambitious plan, but I make no apologies for that. Encouraging the growth of the creative industries is central to the Government's economic and social

strategies, and the film and audio-visual sectors are key elements of that.

In order to develop further this seven-point plan, I have asked my Films Minister Tom Clarke to co-chair with Stewart Till of Polygram Filmed Entertainment an all-industry working group. That group's objective is to produce an agenda for action, both by the Government and the industry itself, to build and sustain a vibrant film sector in the UK with the aim of doubling the share for British films in the UK market. The review will be finished by February and its conclusions and recommendations will be widely circulated and discussed.[2]

The ability to develop brilliant new ideas in all sectors of the economy has always been, and continues to be, a great British strength. For recent evidence of this, you need look no further than Nevada, where British engineering, determination and courage delivered the first ever supersonic car. Where we have tended to let ourselves down is in the commercial exploitation of our ideas. This applies just as much in the audi-visual field, where our tremendous talent base is rarely matched by box-office returns for British movies at home or abroad. This is getting better – but we shall have a long way to go.

The new Labour Government is committed to giving our creative industries the support they need to realize their full potential as we enter a new millennium. Developing our film and audio-visual industry is a key component of that strategy. I look forward to working closely with film-makers from Hollywood and around the world to deliver our fundamental aim of a strong, profitable and sustainable British film industry.

2 The report of the Film Policy Review Group, *A Bigger Picture*, was published on 25 March 1998. Its proposals include the creation of an all-industry fund to support development, training and distribution; new measures to assist both financing and marketing; the opening of a British film office in Los Angeles; a redirection of some National Lottery support into scriptwriting and distribution; a new emphasis on training; a redefinition of what counts as a 'British film', and a rationalization of the various public bodies supporting the film industry.

Pennies from Heaven:
Public Broadcasting in the Digital Age

A speech to the Royal Television Society Biennial Convention,
in Cambridge on 18 September 1997

This is your first address at one of these biennial conferences from a Secretary of State for Culture, Media and Sport. That title, incidentally, is not meant to convey any contradiction between culture and the media. I certainly regard television as a key element – if not *the* key element – in our national culture. The title merely emphasizes that we fully recognize that broadcasting is a major industry as well. Television is indeed at the heart of the main themes of my re-christened Department. It is television which for many provides the main source of cultural excitement and the main window on what the nation and the world has to offer. And broadcasting, as its very name implies, offers benefits to the many, rather than the few.

Specifically, it is television which brings to most people the work of the creative industries which are so important for the future wealth of this country. Television supports a range of talents, including writers, musicians, producers, actors, designers and journalists. It is an essential part of our cultural life. The quality and diversity of British television has been remarkable: this should continue to be its hallmark for the future, and should underpin our policy aims for the industry. Here are the three essential ingredients for policy: diversity of provision, genuine choice for the viewer, and quality of content. Nurturing these three objectives is what our new Government's media policy is going to be all about.

Helping to sustain an environment in which both quality and

diversity continue to flourish is not only in the interests of viewers, but in those of the industry, in what is becoming more and more a global market-place. As we focus on the role of creative industries through the work of the Creative Industries Taskforce, we are particularly conscious of the benefits of a dynamic and innovative television industry. As I have remarked before, we are living through a great sea-change in the British economy. The industries that depend on creative skill and intellectual property for their added value – media, design, film, fashion, music, publishing and cultural endeavour – are the ones that will deliver the growth, the jobs and the international success of the future. And television is at the forefront of that movement.

To secure that position, we shall need to ensure that the industry is regulated appropriately, and that is the main issue I shall address today. But there is more to it than that. It will, for instance, be crucial for television to have the necessary skills to maintain its leading role in the future. I have been concerned at the evidence of an emerging skills shortage in parts of the industry; I do not want to see the changing face of production and programme-making leading to less training and fewer people learning skills. That is why I so warmly welcome the work of Skillset, the official industry training organization. The Government is firmly committed to sustaining a skilled workforce so that the television industry can retain its competitive position.

The theme of this conference is what degree of regulation broadcasting will need in the multi-channel future. As you will know, the Government is pledged to review the regulatory structure for broadcasting and for communications generally, and we shall do so. I propose in this speech to concentrate on the main elements of that task.

Before I do so, however, I should like to turn briefly to digital television. That was the main topic of your previous biennial conference. Before your next one, it will have begun – on cable, on terrestrial channels and on satellite. Bruce Bond, the then

managing director of business communications for British Telecom, set out very forcefully at the 1995 Convention and in his Fleming Lecture last year both the threats and the opportunities which arise from these and related developments, and suggested what the industry and government might have to do to secure a leading role for Britain in the global market. So it is perhaps worth setting out where I stand.

Put simply, I want digital television to succeed, on all delivery platforms. I want digital services to develop on the basis of fair competition between providers to bring content to consumers – not as a war between different receiving equipment or delivery systems. I also want to ensure universal access to the current free-to-air public-service channels, and I want that access as soon as possible to be through digital services, so as to end the current wasteful use of valuable radio spectrum for analogue terrestrial broadcasting. My aim for the future is for the viewer to have a ready and easily-made choice between programmes that are free and those that are paid for; between channels that come via terrestrial, satellite or cable means. And there should be no undue obstacles put in their way in making those choices.

To a large extent, it will be for viewers – or, if you prefer to use the phrase, the market – to decide which digital services succeed, on which platforms. But it would be idle, or indeed disingenuous, for the Government simply to leave it at that. In broadcasting, we are dealing with an industry which plays a crucial role in determining individuals' sense of their own identity, moulding their tastes, interests and consumer preferences. It is, quite simply, rather more important than regulating competition in the provision of goods on the supermarket shelves. We are also, crucially if more prosaically, talking about an industry which has always been very heavily regulated. The transition from that regulated past to a more abundant and unconstrained future is one which itself needs to be carefully managed. I see the Government as having two important roles to play in this process.

Firstly, we act with the regulators to prevent any anti-

competitive abuse of market power, across the whole 'chain' of linked commercial activities which now constitute the process of creating material and delivering it to the viewer. This provision applies to the development of electronic programme guides as much as it does to conditional access rules. The Independent Television Commission (ITC) and OFTEL, the telecommunications regulatory body, have already made good use of their powers by setting a framework in which further competition on the basis of content can develop. They will need to maintain their vigilance, and indeed are currently examining various developments closely. But I am confident they have both the will and the necessary powers to promote competition in the interests of the viewer. These powers, moreover, need to be seen in the context of the strengthened general competition regime which we shall be proposing in the Competition Bill during the current session of Parliament. This is, of course, a point noted earlier this week by Don Cruickshank in his speech to ENACT.

The second role for government in the digital field is to act as necessary to expedite the take-up of digital receiving equipment. This is not a question of crude subsidy or of interference with the proper operation of the market. But it is a general priority across government to make the benefits of the Information Age as widely accessible as possible as quickly as possible. I intend to examine very carefully the options for expediting the transition to digital, not least because of the national resource represented by the freed radio spectrum currently occupied by analogue terrestrial broadcasting. As a first step, my Department and the Department of Trade and Industry (DTI) have commissioned independent research to explore the technical options, the potential role of the various players and the economics of the transition to digital. That initial study should be completed later this month.[1]

1 My Department has since published the NERA report to which the speech refers, setting out the options and likely financial and other considerations and the possible timescales for the switch from analogue to digital. We are also conducting a widespread consultation on the conclusions of the report, and the

There is another benefit in ensuring the early transition to digital broadcasting, in that it will put the UK at the cutting edge of developing new services, including interactive ones, as well as new technologies. Digital broadcasting should be regarded as a creative opportunity, providing a spur to British talent and innovation. It should give Britain the chance to make a valuable contribution to the growing global communications revolution.

I want now to turn to my main theme of the future regulation of the industry. Our objective is to secure good quality and diversity in broadcasting and to ensure acceptable standards of taste and decency, while doing what we can to promote its competitiveness in the global market-place. This points to regulation with a light touch. We aim for the minimum level of regulation necessary to achieve those objectives which cannot be secured by other means. We recognize that in a field in which both technology and market perception is changing quickly and continually, it makes sense for government to establish a framework for future regulation which has sufficient flexibility to respond to changes as they emerge.

The obvious starting point for considering broadcasting regulation is the future of public-service broadcasting. There is a simple-minded view that the profusion of the multi-channel digital future will render public-service broadcasting unnecessary. That view is profoundly mistaken. There may well be reasons for reaffirming and to some extent reinventing public-service broadcasting, but it will remain highly relevant. Public-service broadcasting covers the whole field of information, education and entertainment; its purpose is to speak effectively to the human intellect and emotions; it reflects the spread of society as a whole. It must be prepared to challenge, and be awkward, and be difficult as well as easy. And its defining characteristic is that it puts the viewer first, and no one else.

various options facing government. The need is to find the quickest possible way of making the transition, without disadvantaging those – especially anyone with limited means – who are dependent on analogue.

That is why two things are important. In the first place, public-service broadcasting is as much about perspective as variety of content. Public-service broadcasters do not simply provide certain kinds of programmes which the commercial sector is unlikely to offer. They provide programmes of all kinds solely to entertain, educate and inform, rather than for commercial gain. That purpose will remain fully valid, and it is one which is important to viewers. Further, public-service broadcasting acts as a quality benchmark against which all other broadcast material can be measured, and which at its best can serve to drive up standards across the board.

Secondly, while the multi-channel, multimedia future offers the prospect of increased choice and diversity, it is no guarantee of continuing standards across the field, nor indeed of increased competition. The public-service broadcasters have a track record in providing high quality and in sustaining a diversity of viewpoints. It would be folly to throw that away.

Public-service broadcasters also have a wider role to play in national life. The BBC is more than just a broadcaster; it is a cultural institution which supports a number of activities. It runs orchestras, and one of the most successful concert programmes in the country. It commissions plays. It makes a valuable contribution to education, both formally and informally through its support of distance learning and initiatives such as the recent 'Computers Don't Bite'. These initiatives may be given further impetus by the Government's plans for a University for Industry. In addition, the BBC has also made a valuable contribution to promoting and maintaining the skills-base within the broadcasting industry, a role which I hope it will continue to fulfil in the future. Channel 4, too, has nurtured talent in the television industry through its encouragement of innovation and experimentation and its support for independent producers, and ITV also plays a distinctive public-service role.

But, if public-service broadcasters are to continue to thrive, they must be seen to adhere to their public-service remits, and to

demonstrate their accountability to the public and to democratic bodies. I welcome the proposals which the BBC has already advanced to improve its accountability to viewers and to Parliament, but I hope that further progress can be made. As for Channel 4, in producing proposals for its future funding as the funding formula payments cease, I have sought to ensure that the new money available to it is devoted to fresh, innovative, UK-produced programming. I shall look to the ITC to strengthen Channel 4's commitment to such programming in the forthcoming review of its licence. I propose at the next legislative opportunity to recast Channel 4's remit positively, rather than simply defining it – as at present – as what Channel 3 is not. Similar questions arise for S4C as it approaches its enhanced role in the digital future.

To sum up, I do not subscribe to the view that the digital future will in any way render public-service broadcasting obsolete. Far from it. It will be more important than ever. However, it needs to be something distinctive and special, with correspondingly distinct regulatory arrangements, rather than the regulated norm from which everything else deviates. That in turn means the public-service broadcasters themselves need to rise to the challenge of re-stating their purpose and demonstrating to the public that the purpose is indeed met.

Of course, for many purposes the terrestrial commercial broadcasters are part of the public-service framework. Certainly I value as much as anyone the role which ITV has played over the years in providing in effect an alternative commercial public-service channel. I am sure that ITV will strive to maintain its tradition of developing a thriving home-grown UK television industry, not least because elements such as the regional emphasis and the prevalence of UK-produced drama are as much crowd-pleasers, delivering the audience to advertisers, as they are dutiful fulfilments of licence requirements. Anyone who disbelieves me should look at the percentage viewing figures for the local Selkirk opt-out in Border Television. Local and regional flavours for programmes are widely popular. That is

one of the reasons why I feel so strongly that, in the world of ITV mergers and takeovers, the *regional* character of programming and location of programme-making must be upheld.

Increasingly, however, the terrestrial commercial broadcasters need to be seen for the purposes of economic regulation as part of a single commercial market, irrespective of the means of delivery. The forthcoming consideration of Channel 3 licence renewals gives the ITC a timely opportunity to reassess the true commercial value of the privilege which access to the restricted terrestrial frequencies conveys in the much-changed competitive environment of the late 1990s. In its continuing policing of the existing framework, the ITC will need to monitor the distinctive commercial restrictions imposed on terrestrial broadcasters – for example, on their advertising and sponsorship. Moreover, as media markets start to converge, definitions and distinctions previously taken for granted will start to be eroded. The Government and the ITC will in due course need to review the controls placed on broadcasters as opposed to other media.

I would, however, add a note of caution. We must keep reality firmly in view. Some 75 per cent of UK households still rely on terrestrial channels. That rightly has unavoidable regulatory implications. The vast majority of the UK public is quite satisfied that it knows what television is. Not only does it know what it is, it cares deeply about it in a way that it perhaps does not about other media. Nevertheless, we are prepared to consider thoroughgoing options for change as we devise the regulatory framework for the future.

I said just now that viewers care about television. What that means, of course, is that they care about content. But content is also an area where convergence is already starting to undermine the current distinctions between regimes based on delivery mechanisms. I am not thinking here simply of the convergence between broadcasting, computing and telecommunications. There is also the parallel convergence between television, cinema, video, radio and the press. To consider the kind of issue which in the future will be thrown into ever-sharper relief,

we need only remind ourselves of the many ways in which a feature film can currently reach the viewer, and the many different regulatory regimes applying to that same content: different regimes which often lead to different versions of the content.

In principle, some move towards a more unified set of standards, defining what is or is not acceptable, must be desirable. But that does not mean that a monolithic approach to enforcement is either sensible or practicable. People's expectations will continue to differ according to the medium and according to the nature of the transaction. What is acceptable on an encrypted subscription channel will not necessarily be acceptable on free-to-air broadcast media. Enforcement practicalities also, of course, vary. It is no use pretending that the same content-control regime can plausibly apply to the Internet and to public cinema exhibition. In examining the future of content regulation, we shall seek to balance two often conflicting considerations: meeting justified public concern and keeping regulation to the minimum. For each method of disseminating material, there should be a convincing means of protecting children, or preventing widespread outrage to public feeling, which is nevertheless both proportionate to the risks involved and effectively enforceable in the event of transgression.

The final key aspect of broadcasting regulation is the distinctive competition regime applied to the media. The communications media are far more than a market; certainly far more than a utility. There will remain a need for plurality of voice in a healthy democracy. More widely, the media play a key role in reflecting the totality of a society's culture, and reinforcing its identity – I ought, indeed, to say its various diverse identities. Standard competition regulation – even as enhanced by the forthcoming Competition Bill – will not always meet these concerns because it is rightly focused on the relatively narrow question of avoiding commercial market dominance.

Market convergence will, however, have a major impact on the distinctive competition controls applied to the media. Any effective regulation of competition in the broadcasting industry now needs to consider the whole range of activities involved in bringing the creative product to the viewer. It is no longer sufficient to look at who holds the broadcasting licences. We are all well aware that the key battles of late have related to adjacent issues such as conditional access; channel 'bundling' and the control of key rights, above all to sporting events. These matters have a direct impact both on market dominance and, more broadly, on effective plurality of voice and choice for the viewer. This wider scale of potential regulatory concern has meant that the various UK regulatory bodies involved need increasingly to work together. The ITC, OFTEL and the Office of Fair Trading are rising to that challenge, and my Department and the DTI will continue to assist them in doing so. But, while we are confident that the existing structure can be made to work, it is clear that the distinctive arrangements for regulating media competition need to be reconsidered as part of the overall re-examination of future communications regulation.

It has long been Labour party policy to modernize the regulatory framework. Indeed, I said as much during my former engagement with these matters as a Shadow Minister. But the issues involved are complex. We shall need your help – and help from others – in charting the way ahead. Our aim will be to generate a widespread and informed debate, as a prerequisite to firming up our proposals for change in due course. This is something we need to get right and cannot rush.

Let me also emphasize that our proposals do not imply a blanket regulator for the media, or even for television. They are, however, likely to mean that the regulatory structure will not in future be defined exclusively by the particular medium concerned. We need to have regard also to the nature of the economic activity being regulated – for example, content creation or delivery to the viewer – and to the ultimate purposes of regulation, such as fostering competition and controlling

objectionable content. Increasingly, these functions and purposes will straddle what we now think of as largely distinct media.

I have one further proposal to make this evening. Britain is the second biggest exporter of television programming in the world. We are ahead of the game in what is a rapidly growing market of great cultural as well as commercial significance. But that is no reason for complacency; rather it is a very good reason for thinking about how we could do even better. There is enormous potential for British programme-makers here: using our talents to the full, the fact that we make the best television material in the world, and the fact that we have the best archives too.

I want to see the industry – the independent production sector just as much as the big broadcasters – exploring ways of working *together* to ensure British programming is in the best possible position to find overseas markets. And where the industry is already working together, I intend to support and encourage it in any way I can. Instead of everyone organizing their export work separately, let us look seriously at what we could achieve if we worked in liaison with each other, with all parts of the industry participating, and government acting to help the process. I have already initiated discussions on this, and want to take further steps to develop the idea in the next few weeks.

I should like to conclude where I began: emphasizing the centrality of broadcasting to my Department. It is an area in which I shall personally be taking the policy lead as we enter the digital future. We are in a transitional phase, moving from the presumption that television is closely controlled to the presumption that it is one part of a competitive, commercial, multimedia content production and delivery industry. In future, we need television regulation which is carefully tailored to achieving specific ends, and calculated as little as possible to distort competition or hinder development. Positive regulation for the future will be in support of public-service broadcasters

with remits for quality and inclusiveness and in support of competition to secure choice and diversity for the viewer (those key aims again: diversity, choice and quality). It will be one of the instruments by which the Government seeks to do its part in nurturing a dynamic and competitive broadcasting industry which can compete effectively in the global communications market.

Living in the Real World:
Access to Intellectual Property

*From a speech to the Institute for Public Policy Research at
Millbank, London, on 30 January 1998*

Anyone who has studied economics, at even the most
rudimentary level (and this last category certainly includes me),
will be familiar with what is called 'the economic problem'. We
are told it is the problem of satisfying human wants and needs,
which are for all practical purposes unlimited, from productive
resources which are scarce. Those resources are usually
categorized as land, capital and labour. The last of these refers
to the stock of human skills and talents which can be used in
producing goods and services.

That scarcity of human skills and talents is at the core of the
issues that concern us here today. I am referring to a narrower
concept, of what might be called creative talent. Artists, writers,
musicians, architects, designers, movie-makers, dancers, actors
and sportsmen and women – to name only a few of the many
groups who make up this pool of talent – are the essential input
to a field of activity which is of great and growing importance in
the world's economy, not least in Britain.

The burgeoning creative industries are just one aspect of the
modern Britain to which this Government is committed. One of
the key themes of New Labour has after all been the need to
modernize our approach to industry and business – not just as a
party but as a country too. It is about learning how markets can
best be helped to produce a synergy between producers,
consumers and community. Modernization is about living in
the real world. It is not about state control of everything. Nor is

it about slavish devotion to the market, come what may. Rather it is about bringing together the regulatory, fiscal and public-policy elements of the framework to enable rapidly growing new economic sectors to develop to their full potential, at home and in international markets.

The creative industries are precisely such a rapidly growing sector. These are profound changes in our economy, and our policy approach to industry needs to take account of these modern realities. New Labour, therefore, is about approaching the needs of industry and business with a practical, not a dogmatic, view. We must create a policy environment in which genuinely competitive market thrives, and thrives not only effectively but fairly. *That* is the policy goal.

Demand for the products of creative talent has never been greater. For a number of reasons, people have far more scope for recreational and cultural activity than has ever been available before. There is an unquenchable and growing demand for entertainment, for information and for education. People want fresh, unexpected, original offerings in all of these fields which require rare talents to produce.

In the past, scarcity of talent was mitigated by factors which limited access to its product. Reproduction and distribution have been both imperfect and costly. All those who are old enough to remember listening to musical performances on AM radio or watching the Cup Final on a small monochrome TV with a none-to-clear picture will know what I mean.

Those limitations on both the quality and quantity of material which can be distributed widely have eased as technology has allowed better and cheaper reproduction and transmission, in broadcast and other electronic media, and in print. I share the concern that many of you will have about the same need for adequate protection of copyright, and effective safeguards and remedies against piracy. I shall say more on this later. But the adoption of digital technology across the communications industries creates the possibility that more people will have better access to more material than ever before.

New ways of transmitting information and creative material have led to an explosion in the *availability* of that information. It is making sure that both the providers and consumers of the information can have ready access to the networks that policy has to concentrate on. It is a high priority for the Government to ensure that the benefits are available to everybody.

Digital broadcasting will offer more channels, better quality and new kinds of services to the viewer and listener. It will also create a range of new possibilities: home shopping, video on demand, Internet access and e-mail through your television. Some of these services will, I suspect, develop more quickly than others. The new technology will also in the near future allow broadcast-quality video and sound to be transmitted on the Internet; we already have sound broadcasting on the World Wide Web.

All of this means that in future technology will in principle allow any kind of content, once digitized, to be transmitted on any network. I suspect, though, that consumers will for some time continue to prefer certain types of apparatus for accessing particular types of content. I have no doubt that Web-TV and Webcasting have great potential. But I do not think that many people will want to sit at their desk watching a two-hour film on their computer screen, or that they will find relaxing in an armchair in front of the television the right situation for manipulating complex data.

Convergence raises some challenging issues for all of us. The Government is committed to carrying out a review of the future of regulation in the converging fields of broadcasting, tele-communications and information technology. Given the complexity, and the uncertain pace and direction of future developments in this area, we have to proceed with caution. If these sectors are to realize the potential benefits that new services offer, both for our citizens and for our economy, then we need to get the regulatory framework right.

This will require the involvement of all parts of the industry in helping us to chart the way ahead. The Government's aim is

to stimulate a widespread and informed debate and that process has begun with the European Commission's Green Paper and the Culture, Media, and Sport Select Committee's Inquiry into Audio-Visual Communications and the Regulation of Broadcasting.[1]

We should never forget, however, that viewers want to watch *programmes*, not delivery platforms on regulatory categories. It is content above all that matters. And what will be the implications of convergence for producers of content? What effect will it have, for example, on the structure of the industry? One view is that the growth in the number of channels and services must be beneficial to content producers. New developments will offer not only greater demand, but the possibility of a new framework for trading in rights.

I know that optimism about the future for the production sector is neither universal nor unalloyed. I am frequently reminded that, in countries where multi-channel television is well established, viewers are commonly offered a diet of repeats and low-cost programming, rather than the variety, quality and originality that we have come to expect in Britain.

The audience is unlikely to grow in line with the amount of service on offer, and therefore many broadcasters may find it more difficult to generate revenue. (This is of course the flip side of the 'economic problem' I started with.) And the investment required to create new services – bearing in mind the increased need for ancillaries such as conditional access and collection of payments from subscribers – will undoubtedly be considerable. So a pessimist would ask, where is the revenue going to come from to pay for new, quality programming?

There is an issue here, but I would say that quality programming is the key to solving it. Give that away, and you give away your audience. Few will want to buy the new technology for the sake of owning the latest gadget. It will be

1 The Government is also issuing its own consultation paper on convergence and the regulatory implications of the disappearance of barriers between different types of media. We will welcome the widest possible debate.

bought by most of us because we want access to the content it offers. It is no good having Conran (either Terence or Jasper) design your restaurant if the menu is cheese sandwiches. We have gourmet viewers in this country, whose palates have been educated by watching the best quality programming in the world. And they will expect that quality to be sustained, if not improved, in the new services which they are invited to buy, at least initially, at a price premium over the old ones.

One of the matters you are rightly going to consider in this context is that of the rights to broadcast sports events. Subscription broadcasters have found an audience that is willing to pay a higher price for a more extensive package of television channels. With a relatively small but growing audience, they have the ability to generate a considerable revenue stream and have weakened the link between commercial clout in the content market and the ability to command a mass audience. No one can quibble with that. They offer a distinctive service and have, through courageous and imaginative development of their business, found a healthy customer base.

Subscription broadcasters can therefore often outbid others with a much greater audience for content they see as vital to their success. And many sports have been beneficiaries of the resulting competition for rights to their events. But the consequence is that those events are no longer as accessible to the mass of the population as they once were.

I have no quarrel with these deals, as long as they result from an open, competitive bidding process which is fair to all parties. The rights holders are of course entitled to generate income for their sports. They have in many cases invested in marketing the event, improving facilities and developing the necessary talent: it is understandable that they should expect a return. But there are some events – few in number but of great importance – whose significance and value goes far beyond that which is created by the rights owner. Such events cannot merely be treated as commodities for sale to the highest bidder.

The widespread interest they generate is partly the result of

the long history of the event, of the fact that it brings together major national and international participants, of the involvement of British national teams, and – we should not forget this – it is also the result in some cases of a long history of being broadcast to the nation on free-to-air television. For events where this element of public property is so significant, we must take steps to ensure they are available to all those who wish to see them.

The Government is committed to the principle behind the listing of major events, which is that those with that special resonance making them a component of our common national calendar should be freely available. The task before us now is to identify which they are, and to improve the listing process to render it more visibly fair to all concerned.

To that end, we consulted widely in the summer on the criteria to be used in reviewing the list. We reported on the outcome in November, and published the criteria we had adopted following the consultation. The criteria we have set out to indicate whether a sporting event should be on the list for free-to-air broadcasting include: whether the event has a special national resonance; whether it is an event that serves to unite the nation; whether it represents a shared point on the national calendar; whether it is a pre-eminent national or international event in its sport; whether it involves the national team or national sporting representatives; and whether it is likely to command a large television audience. I believe that these principles will help to make the listing process more transparent, more open and more equable.

I do not believe that listing can ever be a purely mechanistic process. The criteria set out the matters I will take into account when considering whether an event has that all-important national resonance. They also make it clear that I will bear in mind the practicalities of scheduling full live coverage, and of the impact of listing both on the individual sport and on the development of the broadcasting industry.

I have further opened up the debate by asking an advisory

group, under the chairmanship of Lord Gordon of Strathblane, to consider the events on the list and other major events, and to report their views to me before Easter. Lord Gordon's group is working conscientiously on this complex task and I look forward to receiving its advice. Whatever the outcome of the review, I know I cannot please everyone.[2]

As many of you will know, my Department last year assumed responsibility for sponsorship of the UK music industry. This I was delighted to do, because that industry is a world leader in its field. It is varied, adventurous and an enormous success in both artistic and commercial terms – yes, the two *can* go together.

At the moment the toughest challenge facing the music industry is CD piracy. One in three CDs sold around the world is pirated. Global piracy in 1996 was worth US$5 billion in total, and much of this loss was felt directly by the British music industry. Because of the investment required to make CD piracy worthwhile, and the potential profits, organized crime tends to be involved, with large shipments being made across borders. The music industry's experience in fighting CD piracy can be developed as a blueprint for anti-piracy initiatives in other creative industries which may face similar problems due to the ease of making good-quality reproductions of digitized material.

In talking about the review of listed events, I said that the guiding principle is as far as possible fairness to all. I think that principle of fairness to all concerned is one we should have in mind throughout any consideration of trading in intellectual property. Those who create content, and those who transmit it to the customer, cannot sensibly be seen as rivals. Each needs the other: their relationship is one of symbiosis.

2 The advisory group reported to the Government and public in the latter part of March 1998, including the suggestion for a two-tier system of listing to differentiate between those events that must be carried live and those that must be carried in part or at a later time. The Government is responding to the group's report with proposals for action.

Nothing can be more tragic – or more commercially threatening – than good-quality content failing to find the audience it needs and deserves. And I think I have already said enough about the importance of quality content to service providers.

The role of government is to establish a framework which allows trading in that content to take place on a level playing field. I know that this does not end the discussion, because there is considerable room for disagreement about what constitute fair and reasonable terms. But an essential part of the necessary framework is that there should be adequate protection of rights to intellectual property. The increasing globalization of the communications industries means that such protection can only be achieved by international agreement. My colleagues in the Department of Trade and Industry are very much aware of the need to reach agreement on an improved EU Copyright Directive and to move on to early ratification of the World Intellectual Property Organization (WIPO) treaties. They are working assiduously to resolve the remaining issues, and we hope these goals will be achieved in the not-too-distant future. I have stressed on many occasions that I attach great importance to the early ratification of the WIPO treaties, and I will be doing everything I can to ensure that that happens.

The programme for this conference sets out some fascinating issues of vital importance to the development of the creative industries in the UK. I hope that your discussions today – and indeed all discussions of these issues – will take place in an atmosphere of mutual goodwill and in the knowledge that, in the interests of maintaining our lead in world markets, agreements must be reached.

Design:
At the Crossroads of Science and Art

Adapted from a speech for the opening of the Design Resolutions
Exhibition at the Royal Festival Hall, London, on 27 October 1997

The importance of design in our lives is becoming ever more apparent. Design – whether of products, buildings, organizations or cities – is less and less seen as an add-on, the jam on the bread, but more and more as an essential and integral part of the process of creation. Not an extra, but part of the essence of 'making'.

I am sure many of you will be familiar with the little booklet produced recently by the Design Council which offered fifty definitions of design. My favourite came from a ten year old who said – with great simplicity and profundity – 'Design is important because if it was not designed it would not be made.'

Unlike any other species, human beings make things; and therefore they have to design things. Design is woven into the basic fabric of human society, and that means that a healthy and dynamic society will make sure that it is valued in every aspect of its life – in education, in business, in civic affairs. It will be no surprise, then, if I tell you that this Government takes design seriously.

We are now beginning to witness a breaking-down of the artificial barriers which have separated science and the arts over the last 200 years. It was not always as polarized as this. Before the Industrial Revolution, science and the arts were two sides of the same coin, two aspects of 'creativity'. Many of the great minds of earlier ages excelled across these creative fields. You only have to think of Leonardo, Michelangelo, Bernini or

Brunelleschi, whose artistic genius was matched by their technological accomplishment and their quest for continual innovation. Science and the arts – coming together, of course, in good design – were jointly civilizing forces. Advances went hand in hand. It is no accident that the eras of scientific discovery coincided with flowerings of philosophy, studies in the humanities, and cultural achievement.

The Industrial Revolution, however, changed perceptions radically. Huge leaps forward in technology and science transformed the world, holding out the promise of Utopia. In the bid for continual scientific and industrial progress, the other side of creativity – the cultural side – seemed to play a less important role. One result, it can be argued, is that progress did not necessarily mean a corresponding advance in civilization. There were brave attempts from time to time to bring together once again the worlds of science and art: most notably, of course, with William Morris and the disciples of the Arts and Crafts Movement, who were dedicated to the principle of uniting the useful and the beautiful. I believe that, in the modern emphasis on design quality and style in the process of manufacture, we are now seeing a rediscovery of this simple truth.

An artist, after all, can interpret and illuminate possibilities. The arts have the power to remove the sense of mystery which can cloud people's perception of new developments and speed up the time when they become the everyday. Artists can show relevance – and irrelevance – in a very immediate fashion. Artists can also show scientists and technologists the practical potential of their work. Good design is not just about making an object of use also an object of beauty. It is also about improving the usefulness at the same time. The creative vision and imagination of the artist can help to improve what technology makes possible. The unique perspective an artist brings to the process of creation has supremely practical applications for science and technology.

Design, therefore, stands at the crossroads of art and science.

The synergy between the two makes each greater, and the whole more valuable, than the sum of its parts. The extent to which this matters was brought home forcibly to me when I visited one of the country's top car design studios a few weeks ago, a multi-million-pound state-of-the-art facility, where the managing director told me: 'Most people don't understand that the car industry is in fact a fashion business. It starts with design, not with engineering.'

The Government's view is that we have a long way to go as a nation in according good design the place it deserves. But we also have enormous assets. We have some of the most talented and innovative designers anywhere in the world – and in almost every part of the design spectrum, from fashion and graphic design to product design and engineering. Our job as a government is to help create better opportunities for our designers, by stimulating excellence, helping talent to find an outlet, using the enormous power of government procurement to set high standards, and promoting a fuller and more critical appreciation of the value of good design at every level of our education system.

It is often said that we live in an increasingly competitive and global economy in which the only reliable source of advantage for any nation is the imagination and skills of its people. Britain is a country with a long and vibrant tradition of innovation and creativity. That is not an argument for complacency but it is an argument for confidence. There is plenty of evidence here this evening that such confidence is well founded.

It Could Be You:
The Future of the National Lottery

*A speech to the Lottery Monitor Conference,
at the Connaught Rooms, London, on 24 September 1997*

Now is a particularly pertinent point to take stock. The National Lottery has been running for nearly three years; we are precisely halfway between its launch and the millennium. And, of course, a new Government is now in place – a Government keen to seize the opportunity to change things for the better, to build on success, to learn lessons from the past and to look to the future.

A decade or so ago, when debate was raging over whether we should have a National Lottery here in Britain, I do not think anyone had the faintest idea how popular and successful it was going to be. Some £5 billion a year has been spent on tickets or scratch cards, £10 billion or more is being raised for good causes over the seven-year period of the franchise, and 90 per cent of the population participates on a regular or occasional basis. And all of us have had that heart-stopping moment when we discover every week that we have not, after all, become an overnight millionaire.

The Lottery has proved to be something from which millions of people derive genuine fun. But it has also provided a real boost to the overall funds available for a range of activities that are essential for our quality of life, but would not normally attract vast governmental resources. Through the ages there has been a fine tradition of lotteries financing the desirable things of community life, as opposed to the normal responsibilities that should be shouldered by all of us in our role as tax payers. The

building of the British Museum, for example, was financed by a lottery (though the man operating it ran off with half the funds), so it is surely appropriate that the rebuilding of the museum for the millennium should also be financed that way. Lottery funds should not be used to employ teachers; but they should be used to help establish after-school clubs. This is a vital distinction, to which I shall return in a moment.

The timing of this conference is good because, as you all know, in July we published a White Paper outlining our vision for the future of the Lottery: *The People's Lottery*. It is more accurately a 'White Paper with green edges', since it is very much a consultation document; it was designed to ask all kinds of people with an interest in the Lottery what they thought of our proposals and how they could be improved upon.

This consultation has been extremely useful. We have already received more than 400 responses and it is gratifying that the overwhelming majority of these are in favour of our ideas. People working in education and health appreciate the way the Lottery is now being widened to include them, and those in walks of life that already benefit welcome our more strategic and flexible approach. Also, of course, we have been given much constructive advice and many suggestions on detailed implementation of the proposals. I am glad to know that there is such wide interest and involvement in the future development of the Lottery.

Already the Lottery is part of our lives and an established part of our culture. But it could be even better. The Lottery will be with us for a long time and it is surely here to stay. As life changes in many different ways, so too the Lottery will need to reflect new priorities and new concerns. It provides us with an important tool for the way in which we plan, pay for and enjoy public amenities. As one element in the partnership between central and local government, the voluntary sector and public sector, the Lottery contributes to the overall culture of public-amenity provision. We want to put in place a framework that allows the Lottery to respond to needs, not just in the short

term, but in the long term too. As a new government, we now have the chance to do that and to reorient the Lottery so that it reflects more closely the people's priorities.

It is crucial to have public confidence in the Lottery – in how it is run, in where money goes, in how money is given out. We must have the public on board if we want to ensure its successful future. After all, it is the people who play who make sure the Lottery continues week after week. So the benefits must be more widely spread, must be responsive to need, and must include new areas – particularly those of health, education and the environment.

The White Paper outlines a series of initiatives to transform the quality of Lottery spending. There are four main ways we want to do this: creating a new good cause for health, education and the environment; improving distribution for the existing causes; establishing the National Endowment for Science, Technology and the Arts; and better operation and regulation of the Lottery.

The Bill I will introduce later this year will set up a new good cause for health, education and environmental initiatives.[1] These are the key areas that ordinary people are concerned about. We now want to use Lottery money to make a difference, to attack targeted areas of need and produce significant improvements, particularly in regions of greater disadvantage around the country. This new good cause will be called the New Opportunities Fund because it will provide new opportunities for all.

The New Opportunities Fund will be a small, strategically focused body covering the whole of the United Kingdom. Its board will be made up of people with expertise in the specific areas it is to fund, as well as knowledge and awareness of the needs and circumstances in the different parts of the UK. As a small body, it will need to draw on the skills and experience of

1 The National Lottery Bill has now been given full consideration in the House of Lords, has received its second reading and committee stage in the House of Commons, and is expected to reach the statute book by the summer recess.

others, so it will work with 'partner organizations' to design and deliver the initiatives to meet the requirements in each sector.

Local authorities will of course be key movers here. They will have to engage actively with the New Opportunities Fund and play an important role in encouraging, co-ordinating and supporting local bids and projects, because the New Opportunities Fund will be designed to meet the needs of local communities all over the country.

The New Opportunities Fund will be different from the existing good causes and distributing bodies. It will not fund a single sector, but will have a rolling programme of tightly defined and targeted initiatives within the three areas of health, education and the environment. These will be determined by the Government and Parliament after wide consultation – just as the first three initiatives were floated before the general election and again in the White Paper to test them out against public opinion. So the first three initiatives will only be the start. There will be many exciting possibilities for future initiatives that will focus on the environment as well as health and education.

One important measure of any suggestion for future initiatives will be the additionality test; as with all Lottery funding, the New Opportunities Fund will only support initiatives additional to core programmes funded from taxation. The principle of additionality means – rightly – that Lottery funds should add to, not replace, funds that have traditionally been directed to particular areas of activity by the Exchequer. That means that Lottery funding will not be used for the provision of NHS beds or for the replacement of school buildings; rather, it will focus on innovative and desirable initiatives that lie outside these areas, though it may well be able to supplement the basic work of education and health. Lottery funds can add on to existing initiatives (indeed, this is what has happened in the arts and sports) but should not take away from them.

Turning to the initiatives themselves, I would like to give you

some flavour of what they might do. First, information-technology training. Everyone is aware of the IT revolution, which brings with it exciting opportunities for the way people learn – in the classroom, at home and in our libraries. We need to harness this revolution and make sure it is fully exploited. But many teachers are not confident about using computers in the classroom. My vision is, by 2001, to give all existing 500,000 teachers (and 10,000 librarians) the training and support they need to help people of all ages learn how to use information and communications technology. This will be a one-off initiative, designed not to replace existing teacher-training courses but to give the cohort of non-computer-literate teachers and librarians the chance to develop their own and their pupils' skills. We will also be ensuring that substantial funds are available for the preparation of digital content, for use in schools, colleges, universities and libraries.

Second, out-of-school-hours clubs. Education does not just take place in the classroom. There are many opportunities outside the school day for young people to build on what they have learned. Out-of-school-hours activities will mean that pupils can take part in all sorts of complementary pursuits. This might simply be a quiet place to do homework or a chance to take part in drama, music, art or sport and team games. The aim is for pupils to gain in self-esteem and motivation – which, of course, helps to raise standards in schools. I hope to see regular programmes of activities which will involve at least half of all secondary schools and a quarter of all primary schools by 2001. And this provision will also make a major contribution to our goal of putting a nationwide childcare strategy in place.

Third, healthy living centres. Tackling inequalities in health is a key Government priority. Our aim is to establish a core network of healthy living centres around the country by 2001. These centres will help people improve their health and well-being and will be tailored to meet the different needs of different communities.

The healthy living centres will have a range of local partner-

ships and will draw in support from and involve local GPs and other primary-care professionals, the private sector, voluntary self-help groups and local people. The centres might provide health and fitness screening in the local community, projects linking arts and health, support to healthy lifestyles programmes in schools, stop-smoking programmes, information about health rights, welfare benefits and much more.

The network of healthy living centres will be additional and complementary to existing facilities. Valuable projects already exist across the country, contributing to local health in diverse and creative ways. This new initiative will help to spread the benefits of such work much more widely. The centres will be situated in the high street, in shopping malls or on housing estates, and they will be readily accessible and welcoming. They might provide day support, meals, advice or counselling for homeless people; offer exercise in 'Lycra-free zones' to help sedentary people acclimatize to exercise; or be drop-in centres where people can get information and counselling on a wide range of health issues.

A further initiative is NESTA, the National Endowment for Science, Technology and the Arts, a talent fund fostering creativity and innovation. Once launched with an endowment from the Lottery, NESTA will act independently from government, working with and through other bodies to achieve its objectives.

Obviously, you are all concerned about where the money is coming from to support these excellent new initiatives. I want to make it clear that this is not about hitting existing distributors. As Secretary of State for four of the five existing good causes (arts, sports, heritage and the millennium), I personally place great value on what existing distributors are doing, and the work of the Charities Board is of enormous value to the voluntary sector. I want to dispel any misconceptions about robbing old good causes to pay for new ones. On the contrary, the sheer success of the Lottery means we are able to help both. Let me explain how this works. The original forecasts made

when the Lottery was launched in 1994 were that £9 billion over the seven-year licence period could be raised for good causes. But no one then knew how successful the Lottery would be. We can now confidently forecast £10 billion over the lifetime of the licence, meaning that £1 billion is available for NESTA and the New Opportunities Fund, while still giving £9 billion to the existing good causes.

Of course, we do have to acknowledge that some distributing bodies may have adjusted their expectations upwards to reflect this success, but it is fair to say that we can still fulfil original expectations and meet the clear public demand for the Lottery to support new initiatives in health and education. We are working constructively with the existing distributors on the arrangements for putting this funding in place. Some of you have questions about where the millennium stream money will go after the Millennium Commission finishes its work. The answer is we will have to review the position across all the sectors when the time comes. No decision has yet been taken.

Perhaps even more significant than the establishment of the new good cause is the part of the proposed Bill that frees up the activities of the existing distributors. I want to make clear the value I place on the work done by them at present, but I also want to explain my vision for the future and how I am working with distributors on this programme of change. I want the view to be more strategic, so the distributors can take account of the need in their areas of activity and then take steps to meet this need. For the first time ever, the Lottery Boards will be required to draw up a strategy for their deployment of funds. This could mean a number of differences in the way Lottery money is distributed: a fairer spread of funding in the light of need across all parts of the UK; the distributors being able to encourage applications to meet this identified need; a greater emphasis on people rather than buildings – this trend has already begun and I want to see it strengthened; and a clearer focus, within existing good causes,

on what can be done to help areas of social deprivation and disadvantage.

We can also make improvements in the way Lottery money is given out. The overall aim is to make the system work better for applicants so that the Lottery money gets to where it is truly needed. For example, many areas that have not been able to benefit very much to date, like children's play, or musical-instrument teaching in schools, can be addressed. Application forms and procedures can be made more user-friendly. A fast-track small-grants system can be implemented, so that local communities and smaller groups have greater ease of access to Lottery funding.

More flexibility on partnership funding can be arranged: I particularly want to give credit to volunteer time and to encourage all members of the local community to get involved in Lottery projects. And decisions can be taken closer to grass-roots level to make sure that Lottery funding fits into local strategies and needs. All of these are changes which will become possible when our proposed Bill goes through.

In addition, our aims for improving the operation of the Lottery itself are to make sure that there is a simple, transparent and efficient system in place for the next licence, after 2001. We are working closely with the Director-General of OFLOT, the Lottery regulator, on how the best possible operator can be attracted – to make the most for the good causes and to remove unnecessary profit. I would like to encourage not-for-profit bidders to come forward and the new framework will facilitate that. Other approaches might also be possible – a management-fee model, or a multi-purpose company, for instance. As long as they meet the objectives of making the most money for the good causes and retaining the public's confidence, all bidders will be welcome.

I also want to make the Director-General stronger so that he has all the tools he needs to regulate effectively. He will have the power to fine the operator for serious breaches in the licence and, helped by an independent panel with expertise in business,

Lottery issues, distribution and consumers' views, he will choose the next operator.[2]

There is much work to be done to change and improve the Lottery and its impact on our lives, but we are building a base for it to continue far into the future. We are designing, I believe, a truly popular Lottery – a Lottery for the people, wherever they live, whatever community they belong to. I welcome your comments, contributions and questions; I welcome the comments and views of the public. In a very real way, Lottery players think of Lottery money as 'their' funds far more determinedly than they do with taxation. We have to handle all the decisions about this money from the public in the best, most sensible and most imaginative manner, so as to achieve the greatest possible added value to all our lives.

2 Since making this speech, I have given further thoughts to ways of improving the regulatory mechanism for the Lottery, and have proposed an amendment to the legislation to turn the regulator into a small Commission, rather than just a single person. This will help to strengthen the hand of the regulator, and will avoid any danger of 'capture' by the influence of the operator.

Into the Future:
The Millennium and Beyond

Adapted from a speech to the Association of London Government at the Horticultural Halls, London, on 7 November 1997

Coming here this morning, I could not help but feel that the Royal Horticultural Halls were a good place to hold this timely conference. Situated amidst the great institutions of state, these halls were designed by Edwin J. Stubbs in the early part of this century for the Royal Horticultural Society's own shows and lectures, but they have since found fame for their use by other organizations. This year the halls have housed London University's exam students, the Mind, Body and Spirit Festival, and a hundred-metre liquid catwalk formed by Alexander McQueen for London Fashion Week. They are clearly a place where the worlds of politics, academia and creativity coexist.

But what is it about this thing called the millennium? Why is it important? Ben Okri began his powerful *Scotsman* lecture in August with an answer: 'The millennium is an illusion; but it is a useful and powerful illusion by which we can become more real. It is not a moment marked out in time by the universe, by nature, by the seasons, or by the stars. It is a moment we have marked out in timelessness. It is therefore a human moment; it is us making a ritual, a drama, a tear on eternity; we are domesticating the infinite. Therefore it is a moment in which the mind of a large section of humanity contemplates and is faced with the larger questions of time, death, new beginnings, regeneration, cycles, the unknown.'

In a way, I suppose, the millennium is an accident of the calendar. The moment at which 1999 becomes 2000 is not even

123

the start of the 2,000th year. But it is almost universally acknowledged, despite this, as being significant; not just for Christians celebrating a religious anniversary, nor even just for all those who measure time by the Gregorian calendar. It is taken by everyone to be the end of something old and the start of something new; a staging post on our common journey. It is a moment when the world comes together and shares its perspective on the past and the future. As such, it may be just a number on a calendar, but it holds the deepest possible significance for us all.

Most of us, I believe, will want to take the opportunity this moment offers us, to reflect on how we have come to this point and where we are going in the future. We will want to assess our lives, our history, our sense of direction, the challenges ahead: not just as individuals but as communities, as nations, perhaps even as a world. This moment when the past becomes the future so much more markedly than in the normal flux of time will give us the chance to draw together in ways that would otherwise be impossible. Here is Ben Okri again: 'We are living on the cusp of wonders and terrors; and there will undoubtedly be vast tensions. Never before has humanity, in such full consciousness, and bound by a largely universally agreed calendrical measurement, drifted towards so momentous a moment in measured time. Minor spirits come out to play and create mischief at Hallowe'en; major spirits might well be abroad as we approach the new millennium.' A pause for reflection, then; seeking to know ourselves better. An opportunity – even an excuse – to search for meaning in the past and in the future.

What is fascinating is that many of the applications that have been coming forward to the Millennium Commission, from all over the country, have very much reflected these two objectives, of understanding the world we live in (knowing ourselves) and meeting the challenges of the future. Because the Millennium Commission was established by the previous government with a purely reactive remit, responding to applications but unable to

solicit them, the process of receiving and sifting the ideas for the millennium has provided a revealing microcosm of the way in which local communities view it, and the conclusions they draw.

When the Millennium Fund was first announced, there was precious little guidance about what the 'typical' millennium project should be. There was no real steering of bids into particular paths, but in fact – entirely spontaneously – particular paths have emerged. Most of the projects that have reached serious consideration have fallen into one or more of five broad areas: environmental sustainability; education; science and technology; community; and regeneration. These are the millennial themes that have come through, from the bottom up, as representing the improvement of the legacy we have in the present and the challenges of the future.

These five themes have found their practical application in hundreds of schemes, large and small, around the entire country. Much of the focus of the national press has been on one project alone, the Millennium Experience in the Dome at Greenwich. The media appear to be oblivious to the simple fact that the Dome represents only one-fifth of the Millennium Commission's work. Some £1.6 billion is going on projects and awards around the whole of Britain. They range from a new University for the Highlands and Islands of Scotland to the world's largest glasshouse displaying the climatic biospheres of the world in a series of disused claypits in Cornwall. They include new bridges over the Thames and the Tyne, a space centre in Leicester, a multimedia technology centre in Birmingham, and an exploration of the mysterious world of genetics in Newcastle. And this is not to mention the regeneration of urban centres from Sheffield to Coventry, a nationwide network of cycle tracks and pathways, and new village halls, village greens and church bells everywhere you care to look. Communities around Britain have put their hearts and souls into bringing forward projects for the millennium, projects that will last, that use the peg of the turning century to create lasting value. This is surely what the millennium should be all about: using the fact of

a crucial moment in time to do something rather special to mark it, to be used and enjoyed and learned from into the future.

The same spirit lies behind the Millennium Awards scheme, perhaps the least known of the current millennial programmes, with an allocated budget of some £200 million. The subtext we have given the Millennium Awards is 'The chance for ordinary people to do extraordinary things'. Acting through partner organizations, from Community Service Volunteers to Help the Aged, they are designed to enable individuals to receive personal awards of a few hundred or even a few thousand pounds in order to follow through ideas and projects that develop their own abilities and self-fulfilment but also offer something to their community. Half the awards will be made available up to and during the millennium year; the other half of the money will stand as a fund from which to draw future bursaries.

London will, of course, be particularly important for us during the millennium. Many of you here in this room – local authorities, voluntary organizations, the Association of London Government, London First, the Government Office and Lottery distributors – are helping to shape London as one of the world's premier cities, perhaps even a city we can legitimately call the cultural capital of the world. This may sound like an extravagant claim, but there is no doubt that London, as well as being the greatest city in Western Europe in terms of population and wealth, is also one of the most dynamic, diverse and engaging places in the world to live in or visit.

The globalization of economic activity and the growth in world travel have not diminished the power of individual cities. Indeed, the commercial and cultural significance of particular cities or city-regions is probably greater now than it has been in Europe since the Middle Ages. They are the engines that drive large parts of national economies. And, as local authorities in every part of Britain have demonstrated in the last decade or more, imaginative policies for the arts and cultural activity have an absolutely vital role to play in generating, or regenerating,

economic success and civic pride. Look at the work of cities like Birmingham or Glasgow or Huddersfield. Look at the cultural quarter developing in Sheffield. And look at the transformation which is happening on the South Bank here in London, with the coming of the Globe Theatre, and the turning of the old Bankside Power Station with millennium funds into a wonderful modern art gallery. Among the things I have found most impressive about this project are the support it has received from the surrounding communities, and the way in which the Tate has valued and used this local involvement. There is a school of thought which says that the so-called *grands projets* benefit no one other than the cultural élites involved in them. I do not buy this argument and the Tate Bankside explains why.

The role of cities in fostering success is as true for London as for any other city in Europe. And with a new mayor and elected city-wide authority in place, to promote the interests of London in ways impossible at present, that will become a role of enormous importance. With the meridian passing through Greenwich, we really can claim that the new millennium starts here. That is not just a good advertising slogan, helping us (I hope) to bring hundreds of thousands of new visitors to Britain – and, what is more, helping them to decide to return as well. It is a chance for us to confirm that London is a world city looking to the future. The Millennium Experience at Greenwich, an extraordinary showcase for British talent, a place to educate, to amuse and to amaze, and linked to a nationwide programme of activity, can be used as a draw to visitors who will remember it all their lives. And to those who say, around the country and elsewhere in London, that the Dome will draw visitors away from other attractions, I say: 'Think bold.' There will be 12 million visitors coming to Greenwich. They will not just want to visit the Dome. We need to ensure that they want to taste and see the whole range of what Britain as a country has to offer.

One of the important points I made about the millennium projects around the country was that they must be about a legacy for the future, not just about a moment in time. The same

has to be true of the London celebrations, and the Dome in particular. One of the best legacies the millennium can leave Londoners is a revitalized River Thames – something we can look to as a living thoroughfare rather than something to turn our backs upon. Together with the Deputy Prime Minister, the Cross-River Partnership, the New Millennium Experience Company and the Millennium Commission, I have been working hard to develop proposals for bringing new piers and new riverboat services to the Thames. How wonderful it would be if we could indeed secure the ambition of river-buses running a regular service up and down the river, not just in the year 2000 but in the years beyond as well.

Around the country, in London and elsewhere, the millennium is going to provide a chance to pause and reflect. A chance to put together buildings, projects, urban and rural spaces, organizations and ideas that enshrine those key reflective themes of environment, science, education, community and regeneration. A chance to build a real legacy for the future. Above all, it will provide a chance to come together to take stock of what and who and where we are. T. S. Eliot, at the end of Little Gidding – the close of *Four Quartets* – put it rather well:

> We shall not cease from exploration
> And the end of all our exploring
> Will be to arrive where we started
> And know the place for the first time.

That journey, and that knowledge, is perhaps what – for many of us – this crucial moment of calendrical time is going to be all about.

Arts and the Man: Culture, Creativity and Social Regeneration

The first annual Shaw Lecture, given at the University of Hertford-shire in Hatfield on 14 January 1998

This is the first in a series of lectures dedicated to the memory of George Bernard Shaw, so perhaps the best place to start is with Shaw himself. Towards the end of his remarkably long life, as the Second World War was drawing to a close, he wrote a rambling but still occasionally powerful book, *Everybody's Political What's What*. It has some wonderful passages in it, and one of them in particular sprang out at me the other day. Shaw wrote:

> The statesman should, I maintain, rank fine art with, if not above, religion, science, education, and fighting power as a political agency. Yet we have not even a ministry of the fine arts; and our promiscuous democracy confronts our rulers with the votes of an electorate taught to regard fine art as sinful so far as it is taught anything at all about it. The situation is saved only by the impossibility of life without art.

It is clear that Shaw regarded the promotion of the arts as a primary duty of government in civil society, as well as viewing artistic content as an integral part of a civilized life. This latter point is a theme to which he constantly returns in his plays. If you want an uncompromising recognition of the importance of art, take this from *The Doctor's Dilemma*: 'I believe in Michael Angelo, Velázquez, and Rembrandt; in the might of design, the mystery of colour, the redemption of all things by Beauty everlasting, and the message of Art . . .' Or look at the ending

of *Heartbreak House*, where the practical man of business – Boss Mangan – is destroyed after seeking refuge in the logical place whilst the explosion in question is greeted with exhilarating glee by Hesione and Ellie – 'It's splendid: it's like an orchestra: it's like Beethoven' – who have refused to take shelter and as a result survive. The wild aesthetic spirits survive, the pragmatic world is destroyed. This is perfect Shavian table-turning, and it has its roots in the need, as he put it (quoting Shakespeare), for everyone to have music in their soul. Poetry triumphs over pragmatism.

This is a constant theme in Shaw: the artistry in the individual winning out; the romantic flying free from the cautious and down-to-earth. In setting out this vision, Shaw's drama is nothing if not didactic. Sometimes he carries his proselytizing a little too far: we feel, like Keats, that the author is 'putting his hand into our breeches pocket', is belabouring us just to make sure we get the message. In relation to art, and in looking at the responsibilities of government for the arts, his message could hardly be clearer. Art is essential. It is what will win in the end. And the civil state has to recognize this and help.

Or should it? Consider for just one moment the salutary warning he gives to putative Secretaries of State for Culture who might be inclined to intervene: 'Do not do unto others as you would that they should do unto you. Their tastes may not be the same.' What a wonderful Shavian touch that is: their 'tastes' may not be the same. But none the less I think he would have approved of what – a couple of decades after his death – Jennie Lee was able to do in supporting the arts, and in broadening the horizons of government. Different tastes there might well be, but it was important thirty years ago to support artistic and creative activity, and it remains vital today. Jennie Lee's task needs now to be taken up once more. And Shaw would be cheering us on in the enterprise.

Cultural and creative activity does not only have an impact on individuals, but – through individuals – on wider society. And it is on that interrelationship between culture and society,

and particularly the ability of culture to assist in the processes of social regeneration, that I want to concentrate tonight.

There are three fundamental ways in which cultural and creative activity can influence the nature and direction of a society or neighbourhood. (And I should add that by 'creative activity' I am not simply speaking of the performing and the visual arts, but about publishing, recording, writing, photography, crafts, architecture, software, fashion, design, film and television, and multimedia.) The first of these is by helping to wake people up to their circumstances or situation. Many artists – by no means all – have been rebels. They have seen the role of art as being to ask questions, to raise doubts, to instil a sense of dissatisfaction. All this is perfectly legitimate. Much more so, in fact, than the opposite tendency. Art as hagiography, whether of people or of regimes or of governmental systems, has always ended up as a failure. Well, almost always. Some would argue that this is precisely what Medici Florence or Federico's Urbino were all about. But, on the whole, I think the point holds. Not all artists are rebels or questioners, but many are, and it is a powerful and praiseworthy aspect of art that they are. The ability of the artist to express a common sentiment, or to draw together things that individuals in a community never realized they felt, can be of real artistic value. It can also lead to social realization and a determination to change things. We ignore the power of the arts to awaken us at our peril.

Whilst touching on this issue, let me just share with you the observation of William Morris, the centenary of whose death we marked just a couple of years ago. This grand old figure, who had such an influence on Shaw himself, gave a lecture to the Wedgwood Institute in Burslem in 1881. He told his audience:

> As I sit at my work at home, which is at Hammersmith, close to the river, I often hear some of that ruffianism go past the window of which a good deal has been said in the papers of late, and has been said before at recurring periods. [Note that

he was speaking over a century ago!] As I hear the yells and shrieks and all the degradation cast on the glorious tongue of Shakespeare and Milton, as I see the brutal reckless faces and figures go past me, it rouses the recklessness and brutality in me also, and fierce wrath takes possession of me, till I remember, as I hope I mostly do, that it was my good luck only of being born respectable and rich, that has put me on this side of the window among delightful books and lovely works of art, and not on the other side, in the empty street, the drink-steeped liquor-shops, the foul and degraded lodgings. I know by my own feelings and desires what these men want, what would have saved them from this lowest depth of savagery: employment which would foster their self-respect and win the praise and sympathy of their fellows, and dwellings which they could come to with pleasure, surroundings which would soothe and elevate them: reasonable labour, reasonable rest.

After reading *that* wonderful torrent of social passion, let no one try to convince me that art cannot move minds and help to drive a determination for change.

The second way in which cultural activity has an impact on wider society is through the developing fulfilment of individuals themselves. This is where the role of education becomes so important and it is why I regard the nurturing and succouring of the creative spirit in children as being one of the prime duties of an education system. It is why, yes, you need to concentrate on the basics of numeracy and literacy, but you need to set that side by side with a balanced and rounded curriculum that gives pupils a full opportunity to develop their own creative potential. It is why I have been so distressed to witness the decline in recent years of musical-instrument teaching in many of our state schools. The pattern varies around the country, of course. But in many places it is difficult, if not impossible, for a pupil whose parents are of limited means to have access to musical instruments or to tuition. I am working with my

colleagues in the Department for Education and Employment to try to address this problem; and I am anxious to ensure that we can use funds from the National Lottery to help reverse the decline.[1]

Nurturing the spark of creativity through the education system is not just about enabling people to fulfil their own potential, however – nor even about ensuring that the rest of us have brilliant musicians and actors and movie-makers whose work we can enjoy in years to come. It is also about helping the rest of the curriculum. Educating for creativity educates for sound basic abilities in other fields as well, as was highlighted recently by a director of the Gulbenkian Foundation:

> The greatest resource possessed by any nation is the imagination of its people. Imagination nourishes invention, economic advantage, scientific discovery, technological advance, better administration, jobs, communities and a more secure society. The arts are the principal trainers of imagination. They can enrich, not replace, the literacy, numeracy, science and technology we need for prosperity.

It would be difficult to put the point more firmly or graphically. It is in fact backed up by some astonishing research that has been done in the United States by Alan Fox and Martin F. Gardiner. Ironically, they were able to carry out their research, on cohorts of pupils, because of the cutbacks in funding for arts education in the US over many years. They were thus able to compare the performance of cohorts who did have arts education with those who did not. The findings were fascinating. Arts training led, it was clear from their test results, to

1 Since this lecture was given, we have been able to develop a new initiative for the creation of a Schools Music Trust, with backing from the Lottery, together with help from organizations like the Performing Rights Society and Associated Board, and from private-sector companies involved in music and related activities. Funds from the Trust will be able to be used for the building-up of stocks of musical instruments in schools, and for the employment of teachers to offer tuition for those who wish.

improvements in classroom attitude and behaviour. But it also led to substantial academic improvement in maths ability. Interestingly, the same improvement did not show up for other subjects, but there was an obvious link with maths. Indeed, the percentage of students at or above grade level in second-grade maths was highest in those with two years of arts education, less in those with only one year, and lowest in those with none at all.

And we do not just need to look to the United States for evidence. A research project in 1997 in Hampshire schools asked teachers to assess the impact that arts activities had on the abilities of pupils. The results showed a 'positive' impact on the language skills of 60 per cent of the children, an impact on physical co-ordination for 62 per cent, on observation skills for 53 per cent, on creativity and imagination for 83 per cent, and on social skills for 56 per cent. Overall, teachers believed that arts activities had a positive impact on the educational and social skills of at least three out of four children.

The message, it seems to me, is clear. Ensuring that the education of pupils is fully balanced and rounded, and includes strong elements of art, music and creativity, not only helps to keep creative abilities alive, and produce the skills that some of our most important businesses are going to need in the future, but it also helps to produce social citizens and to inform the rest of education too.

The third way in which cultural activity influences society as a whole is through the impact it can have on the regeneration of whole areas. The work that has been done over the last three years by the Comedia group has highlighted the enormous benefits of this. Indeed, the conclusion of Comedia's work – in places as diverse as Bolton, Nottingham, Hounslow, Portsmouth, and the Highlands and Islands of Scotland – is that by far the best way of getting social regeneration off the ground in a neighbourhood or a town is to start with cultural regeneration.

The group's own description of its findings sets out the argument:

Participation in the arts is an effective route for personal growth, leading to enhanced confidence, skill-building and educational developments which can improve people's social contacts and employability.

It can contribute to social cohesion by developing networks and understanding, and building local capacity for organization and self-determination.

It brings benefits in other areas such as environmental renewal and health promotion, and injects an element of creativity into organizational planning.

It produces social change which can be seen, evaluated and broadly planned.

It represents a flexible, responsive and cost-effective element of a community development strategy.

It strengthens rather than dilutes Britain's cultural life, and forms a vital factor of success rather than a soft option in social policy.

That these advantages can flow consistently in the most diverse of communities and from an enormously varied range of cultural activities really ought to give us pause for thought as we consider how best to set about the regeneration of our most disadvantaged areas, and the best ways to combat social exclusion. Some of the detailed Comedia figures are equally compelling. The group's study found that arts projects could embody people's values and raise their expectations. It found that 86 per cent of adult participants had tried things they had not tried before; 49 per cent thought that taking part had changed their ideas; and 81 per cent said that being creative was important to them. And amongst the adult participants, at the end of the study, 52 per cent said they felt better or healthier; and 73 per cent had been happier since they became involved.

This sort of impact is also seen at local level, where projects are undertaken on a particular estate or in a particular street. In

an estate in my constituency, several years ago now, funds were found to employ a photographer for a year to take pictures of the tenants, their lives, their homes, their environment: both to produce a record and to involve the tenants themselves in the creative activity of compiling it. The results were amazingly successful, and very popular. People liked taking part. It gave many of the tenants a sense of purpose and dignity that they might not otherwise have had. It drew them together, in a shared exercise, working as a team, rather than existing as isolated individuals. It certainly helped morale on the estate, and improved people's quality of life.

The same effect can be seen in many similar projects, with an important proviso: the people concerned must themselves be involved. A mural imposed on a wall by artists from outside with minimal input from local residents will be unrespected, probably unloved, and almost certainly vandalized within weeks. A mural decided on by residents, worked on by them, assisted by local kids, has a much better chance of surviving. An Alice in Wonderland mural on the wall of a children's library near where I live has remained untouched for more than a decade now, for precisely this reason. Almost every other available wall space in the vicinity has been subjected to much rougher treatment. Public art is brilliant, but it must be carried out by and with the local community if it is to succeed. But doing it this way can yield very rich rewards in terms of social cohesion.

Sometimes unexpected abilities and talents can emerge. Ordinary people can end up doing extraordinary things. The potential is there in all of us. Take just three examples. The first is the Hartcliffe Boys' Dance Company, which works with boys – and I emphasize boys – on the large Hartcliffe housing estate in South Bristol. It was started in 1994 when, according to the founder, the view was that 'Hartcliffe children wouldn't' – especially the boys. Together with the Welsh National Opera, the Royal Ballet, Ballet Rambert and others, they have developed their own operas, shows, dance pieces, music pieces

and classes. There have been many visits by the children to ballet, and visits by major national ballet companies to the estate. Last year 200 boys spent a week working with the Royal Ballet. The organizer says that 'at secondary level almost all the boys on the estate have worked with, or had the opportunity to work with, a major dance company'. He cites the objectives of the company as '(1) fitness, (2) diet, (3) performance, (4) self-image, (5) excitement, (6) visiting new towns, (7) learning that things are not easy: they have to *work*'. Research undertaken by Education Extra on the estate suggests that those involved in these and other extra-curricular activities do better at school than they did before – and better than those who do not take part. Some of the kids are now beginning to get work as dancers, and film-extras, or are taking their creativity further forward.

The second example is Beacon House, a 170–bed hostel for homeless people in East London. In 1995 two artists-in-residence were appointed. Working with residents, they started by replacing the lino flooring with handmade tiles and substituting beaten aluminium furniture for plastic chairs. Further refurbishment of the hostel has followed and activities have expanded into creative-writing classes and a football club. The housing association which runs the hostel says that the additional cost of the scheme has been more than offset by reduced maintenance costs: television sets which used to be secured in cages now stand unprotected; none of the new items of furniture and fittings have been stolen or vandalized; and hostel residents are now involved with arts activities in local schools.

And the third example is of a leading computer consultant writing in the 1995 *Public Policy Review*, who described a pilot project developing a full-service information network in a deprived urban community in these terms:

We are constantly astonished by the real potential locked up in the 3,500 people who have been through our skills

137

workshops. What is interesting is that our assumptions about age or any other barrier are constantly being rewritten through helping a community to help itself. Most notably, when exposed to the new technologies, we see individuals moving from being passive consumers of other people's material to creators of their own.

The ability of a cultural project to lift the eyes and thoughts and abilities of people in a local community can be demonstrated at a wider town or city level too. Look what happens every year at the Edinburgh Festival, when the city suddenly comes alive with people and activity. (And it is not just the outsiders participating, which was the old charge – that the city residents themselves sullenly tolerated this three-week invasion and then got on with the ordinary business of living for the rest of the year. This effect has now long since disappeared, largely because of the thrill and enjoyment and quality of the festival itself.) Look what happened in Glasgow when it was the European City of Culture for a year. It was able to identify itself very clearly in the minds both of its own citizens and of the world at large as being *the* creative city, building on its existing strengths, and achieving cultural excellence, economic advantage, and social benefit too. In such instances, the impact on the social progress of an entire town or city can be remarkable: started off by artistic, cultural or creative activity.

The spread of 'cultural quarters' in some cities is having something of the same effect. Places like Sheffield, Nottingham and Liverpool are changing precisely because of this. The same lesson is being learned, with astonishing success, in one particular area of the South Bronx in New York. A cultural quarter can emerge from a grouping of small creative firms – and one of the characteristics of the creative industries, of course, is that they tend to be based overwhelmingly on small and medium-sized businesses – often in reclaimed industrial or commercial buildings. From small beginnings thriving creative-industry areas begin to develop, which in turn help to promote

the local economy. There is a symbiotic relationship here, which leads to new places to eat, drink and shop. Creative industries are not nine-to-five businesses. They exist on abnormal hours, on providing for people's leisure time, on informality and super-dedication and frequently on volunteering. The local economy in these areas adapts to longer hours, and tends to become livelier at night. Not only does this in itself create more jobs and change the atmosphere of a quarter, but it also makes neighbourhoods – particularly in the inner city – safer and less threatening. The cycle of improvement continues.

One of the most exciting aspects of this is the way in which old buildings are being reused. We may have changed the name of this Department (rightly, I believe, to give the full flavour of what we are about), but that does not mean that the conservation and, crucially, the use of the built heritage is any less important to our work. There is little value in simply sterilizing the buildings of the past; they need to be used and appreciated if it is remotely possible. The transformation of the docks in Liverpool, the translation of the Baltic Flour Mills in Gateshead and the Bankside Power Station in Southwark into galleries for contemporary art, and the new Tribeca-style fashion for 'loft' living in what were once industrial premises, all show how successful sympathetic development can be. The transformation of the heritage can help with the transformation of an area. To anyone who doubts this, you have only to look at the remarkable rejuvenation of the South Bank alongside the Globe Theatre and Bankside to see what heritage- and cultural-led regeneration is all about.

This is why I feel so strongly that any cross-governmental attack on poverty and social exclusion has to include within it the enormous potential that cultural activity and innovation have to help get a regenerative process off the ground. In terms of what it can mean to individuals in their own lives and morale, what it can mean to neighbourhoods and cities, what it can mean for jobs and a local economy, and what it can mean for the sense of self-worth of an entire area, we cannot and must

not ignore the way in which culture can give a lead.

Shaw would of course have understood this perfectly. So would John Maynard Keynes, who thought about it when he helped to establish the Arts Council. So did Jennie Lee. We must make sure that it is built in solidly to our modern public-policy thinking too.

There is so much to be gained. The most recent Comedia report begins with a quotation from Louis MacNeice's *Autumn Journal* of 1939:

> There is no reason for thinking
> That, if you give a chance to people to think or live,
> The arts of thought or life will suffer and become rougher,
> And not return more than you could ever give.

No Wealth But Life:
The Importance of Creativity

I desire, in closing the series of introductory papers, to leave this one great fact clearly stated. THERE IS NO WEALTH BUT LIFE. *Life, including all its powers of love, of joy, and of admiration. That country is the richest which nourishes the greatest number of noble and happy human beings; that man is richest who, having perfected the functions of his own life to the utmost, has also the widest helpful influence, both personal, and by means of his possessions, over the lives of others.*

John Ruskin, *Unto This Last*

It is small wonder that Ruskin's *Unto This Last* was quoted by the members of the Parliamentary Labour Party who gathered in the Commons for that great reforming government of 1945 as the book which had most influenced their lives and their political thinking. Sadly, it is more neglected these days, but it still stands as a trumpet call to all those who believe that the task of seeking a better ordering of society is not a mechanistic exercise but rather one that sees the needs and aspirations of the *whole* human being. True wealth comes from individual fulfilment in its widest sense, and it is part of the job of government to ensure the conditions are there for that fulfilment to be attained by whoever wishes to do so. The chance to develop creativity – and to enjoy the cultural experiences to which that development leads – is a fundamental part of that process.

Through the course of this book, I have sought to establish how important for our lives, our economy, our enjoyment and our society the nurturing of creativity really is. And I have endeavoured to point to a number of ways in which govern-ment can help that nurturing to take place. Government can

never do the work of creating. But it can and must support those who do.

That is why, in the short time since the general election, we have already put in place a whole range of important changes: major reform of the National Lottery, to ensure that funds can more readily be channelled into support for creative activity; the establishment of NESTA, the new National Endowment to act as a bank for talent; overhaul of the whole structures of support for cultural activity, to get the best possible value out of every pound that we spend; new incentives and backing for films; measures to promote the teaching of music and musical instruments for young people, especially in school; work to protect copyright and intellectual property; a programme of support for the opening up of public libraries with new technology; backing for the move to digital broadcasting; a continuation of free access to some of our greatest national galleries and collections; a new programme of support for the performing arts, to attract and develop new audiences; and the establishment of the Creative Industries Taskforce, to put these industries properly on the political map for the first time ever. And these steps are of course only the start of a longer journey. They do signify, however, how great is the importance we attach to these areas of activity, for both people and government.

Perhaps even more important than the specific measures we have taken has been the setting out of a very clear cluster of objectives for the work we do in government on creativity and culture. I referred to these at the outset, and they stand as a good guide to everything we are trying to achieve. There are four major themes: promoting access, for the many not the few, to things of creative and cultural quality; ensuring that excellence and innovation can thrive; putting creativity at the heart of education, both in the formal school and college system and throughout the rest of life; and fostering the creative industries which will provide much of our wealth and employment and growth in the years to come. Access, excellence, education, and the creative economy: these stand as the great

aims of policy. They also stand as the principal reasons for having such a policy and embarking on the exercise in the first place.

Throughout the previous chapters there have been wonderful examples of how real access for all can be secured. There are of course many others. The boys' dance project on the Hartcliffe Estate in Bristol, transforming the lives of the people involved and helping to regenerate an entire community through the interactive magic of dance. The contemporary art on the Gateshead Metro, bringing the best of modern art out into the everyday world of people's travelling and working lives. The Angel of the North, a grand in-your-face project of public art, now proudly on display as a prized symbol of an entire region. The fine and continuing Lilian Baylis tradition at Sadler's Wells Theatre, of a whole range of cheap seats for every performance that could be afforded by all. (I well remember – when the Lottery grant for the redevelopment of Sadler's Wells was announced, and the tabloids fulminated about the toffs – a local pensioner remonstrating with me about how often she went to Sadler's Wells, and how it certainly was not for the toffs at all. That is the Lilian Baylis tradition, alive and well.) The room at the Laing Art Gallery in Newcastle given over to local organizations to choose their own paintings from the storeroom to hang there for a month. The Tricycle Theatre in North London where Monday night is a 'pay what you can' night, filling the theatre when it would otherwise have been half empty. The fact that you can walk into the Tate Gallery or the National Gallery of Scotland and sit and wonder at a painting or two for half an hour and then leave, without feeling you have to visit the entire collection because you have paid through the nose for it. And the wonderful world of the Internet, opening up vast areas of knowledge for everyone at the touch of a button, available in local public libraries up and down the country, accessible to all and not just those who can afford to have a computer and modem in their own home. *These* are examples of what I mean by access. And they help to open up the glories

of creative activity – as a participant and as a spectator – to the widest possible range of people. As Ruskin would have said, nourishing the greatest number of noble and happy human beings.

The need to promote excellence goes almost without saying. But it is too often assumed that opening up access to the widest range of people somehow inevitably leads to a diminution of quality in what is being experienced. It does not, and it should not. I loathe the distinctions that some people try to draw between so-called 'high art' and 'low art'. What on earth counts as 'high' and 'low'? *Madam Butterfly* at the Albert Hall, packed to the rafters and brilliantly performed? The people of Sunderland, flocking in their droves to buy Prokofiev recordings because they love the theme tune of their football club? Nigel Kennedy playing Elgar's violin concerto like an angel? A brilliant one-man rendition of Kenneth Williams at the Edinburgh Festival which had standing-room-only at 11 in the morning? The steel bands playing at the Notting Hill Carnival? Antony Gormley's *Field* which attracted rave reviews and thousands of visitors wherever it went? *Guys and Dolls* at the National Theatre, sitting brilliantly alongside the finest rendition of *King Lear* we have seen in decades? The Verve, transforming the styles and music of the 1960s into powerful modern idiom? Or the drama of *EastEnders*, attracting vast audiences but unafraid to challenge almost every single assumption we bring to the world of relationships and modern life?

The word 'excellence' would apply to each and every one of these. Some would be characterized by the commentators as high, some as low; some as popular, some as élitist. But such pedantic distinctions pale into oblivion in the face of the sheer quality and power of the creativity involved – and the way in which it draws people of all kinds and from all backgrounds in to it. This is the great thing about creativity. It lends itself to a democracy of involvement, provided we do not officiously seek to place obstacles in its path. All you need to bring – to the

process of creation or to the exercise of appreciation – is the opening-up of your imagination and emotions. Of course, different people have different talents and different sensibilities. But through that interweaving of talent and sensibility, which is the process of creation, excellence and access go fundamentally together. To try to separate them, by developing artificial distinctions, is to do us all a gross disservice.

Part of excellence, too, is the exercise of perpetual innovation. The new is not always good just because it is new, but the work of the creator – of a painting or building or piece of music or designer dress – will often involve a process of constantly pushing forward the boundaries of the accepted and the possible. Sometimes this is disturbing to the rest of society; but, without it, art and culture ossify and ultimately die. The need for us as politicians and administrators sometimes to swallow hard and accept a disturbing direction of innovation is one of the more difficult aspects of cultural policy. But it must be done. Somewhere, of course, there is a boundary line between the difficult, challenging, awkward and critical on the one hand, and the offensive on the other. And sometimes works of innovative art push hard against that boundary. In such circumstances it takes courage to provide support; but we must not shy away from the difficult simply because it is so.

The third great aim of policy is education – and by this I mean not simply the formal education system in school, college and university, important though that is; but the process of lifelong learning and self-teaching through which we all, to a greater or lesser extent, go. The role of creativity and culture teaching in the school system is vitally important, not only for the individual fulfilment of the pupils but for the equipping of society with the creative wealth-makers of tomorrow. That is why our establishment of a Creativity Council to advise on the school curriculum and priorities is significant. It is also why the initiatives that we have put in place to promote the teaching of music – and of musical instruments – in schools up and down the country are so important. Music helps to create a rounded

pupil. It helps to develop skill and co-ordination and team-working and aesthetic enjoyment. It aids the development of skills in other subjects too. And for some it offers future opportunities and a career.

But education, and the part that creativity can play within it, does not stop at the walls of the school. For many, the role of the public library, or the local museum, in developing knowledge and cultural excitement is a vital element of continuing education. Our work on the development of out-of-school-hours clubs, with an emphasis not just on homework but on arts and sports too, will help hundreds of thousands of young people to find new fulfilment. And let us not ignore, either, the benefit that can come from full and imaginative use of new technologies. To anyone who harbours doubts, I would urge them to go along to the Sainsbury Wing of the National Gallery to see the Micro Gallery in operation: a bank of monitors with touch-screen technology, containing the entire National Gallery collection in digital on-screen form. The new technology not only absorbs and excites, but it encourages direct contact with the original works of art. That is education at its most potent. And imagine what could be learned if you did not have to go into the National Gallery in person to call up its treasures on the screen, but could do so in the public library in Thurso or the school library in Truro. Putting educational value into everything we do in support of the creative and cultural worlds is one of the most crucial parts of public policy.

All of this leads to the fourth great aim, which is the promotion and nurturing of the creative industries. In the analysis of figures that concludes this book, the plain facts are very clear. These industries, taken together, add up to over £50 billion of economic activity each year. They are growing. They are employing more people, year by year. They are producing vast quantities of overseas income for us as a country. If you include the tourism and hospitality industries in the equation – which are themselves heavily linked in with the cultural sphere – the figure of £50 billion rises to something around £90 billion.

So these industries represent an exceptionally important part of our economy. One of the things that always saddened me in the past was the way in which the responsibilities of what was then the Department of National Heritage were written off by many commentators as an add-on to the main economic business of government. That perception is now changing rapidly, and not before time. These areas of industry, which rely on individual talent and the creation of value through imaginative skill, are not just part of the enjoyment agenda; they are vital for employment and our economy, too. The sheer economic importance of these fields of activity is now, at last, beginning to be appreciated – not just in the cultural quarter of government, but right across the board.

When James Stirling builds a new edifice in Stuttgart, or Damien Hirst is lionized in New York, or Galliano couture wins plaudits from the critics, or the scriptwriter of *The Full Monty* is hounded round a clamouring Hollywood for his next movie, or British bands play to what seems like half the world in Japan, these are not just the evocation of a new British style and part of a new British identity; these are economic transactions too. As a nation, we have been slow to wake up to this truth, but the evidence is now becoming incontrovertible. Creativity, culture, national identity and the nation's future wealth are all inextricably bound up together. It is skilled, creative people that make the difference. And the proper role of government is to *enable* that to happen.

Individual creativity is where it starts. Twenty-two years ago, when I was a young and eager student spending a year at Harvard studying Wordsworth, campaigning for the Democrats, and discovering America, I went along one afternoon to listen to a Masterclass which was being given by Mstislav Rostropovich. A series of students came and went, and the climax of the event was a session playing the first movement of Dvořák's cello concerto, with a Harvard student called Yo-Yo Ma (now a global maestro) as the pupil. Yo-Yo Ma took his cello and started playing; and for fifteen glorious minutes we

listened in absorbed silence as the most wonderful music swept over us. It was inconceivable to us in the audience that this music could ever be played better. This was perfection. Then suddenly Rostropovich started becoming very agitated, stopped the music, tried to explain what he meant about the *feeling* that needed to be put into the playing, about the need for more than technical perfection, and, because he could not really explain it, he seized the cello and started to play himself. And this music, which we had thought could not possibly be bettered, became transformed into something infinitely richer and finer than what had come before. It was a brief revelation of the way in which the creative spirit can transform even those experiences which themselves seem to be supreme into something deeper, much more moving, and of the greatest value to the human psyche. This is what creativity is at heart about: adding the deepest value to our lives.

Creativity, therefore, is important in and for itself, for its own worth; it is after all better to create than to destroy, better to leap with imagination than to desiccate with pedantry. It is also important for what it can do for each of us as individual, sensitive, intelligent human beings: fulfilling ourselves and our potential. It is important for what it can do for society, because creativity is inherently a social and interactive process, and it helps to bind us together as people. And it is important for what it can do for our economy, for those great surging industries that promise to provide real opportunities if we nurture them well. Important for its own sake, for our individual lives, for society, and for our economic future. How can anyone possibly argue that this is not a proper province of governmental interest? Not to meddle or to interfere, of course; but to argue for, to educate about, to help and to cherish. These are the things the Government needs to do, and I have tried to show in these pages how and why we are setting about doing them.

If we ignore the importance of creativity, then we shall probably stumble somehow into the new century, but it will be an increasingly arid and unfulfilling world. If we embrace it,

however, then the real value of life can be immeasurably enhanced for us all. There is, after all, no wealth but life. Ruskin summed it all up, rather well.

A Summary Map of the Creative Industries

At the request of the Creative Industries Taskforce, Spectrum Strategy Consultants recently undertook a study of the creative industries, intended to produce an economic 'map' of each. The aim of the exercise was to produce a reference document for each industry, outlining its key activities, its contribution to the UK economy, and the opportunities and constraints each industry is currently facing. A summary of the maps produced is set out below.

In many cases, it became obvious that there was no historical, and little current, data available. There are few existing statistics to go on. Spectrum has therefore pulled together the data from a variety of sources, both published and unpublished, and has relied on estimates in some places. Forecasts have been generated for all industries, but should be taken as signposts rather than measured predictions.

Market size is defined by retail sales (including imports) in the UK, and (where appropriate) licence fees, pay-TV and advertising expenditure – i.e. expenditure in the UK market for each industry. Industry size is defined by market size plus exports less imports, when possible; otherwise it has been built up piecemeal from revenue or turnover figures and therefore is a low-end estimate (i.e. value added to the UK economy by each industry).

CAGR = Compound Annual Growth Rate. Inflation is currently around 3 per cent, so a CAGR greater than 3 per cent indicates real market growth.

Advertising

The UK advertising industry is one of the most successful and dynamic in the world. It supports several global leaders.

UK revenues[1]
in 1996
– UK advertising firms had a fee income of £4.3bn

Forecast growth
– Assuming a CAGR of 5 per cent, advertising revenues will reach £7.4bn in 2007

Architecture

The architecture industry is experiencing a period of transition, as the role of the architect changes, but revenues appear to be growing following a very serious slump during the recession.

UK consumer market[2]
in 1996
– Architecture firms had a fee income of £1.25bn

UK revenues[3]
in 1996
– Home and overseas fee income totalled £1.5bn

Exports[4]
in 1996
– Fee income of £250m from overseas
– 42% of which came from Hong Kong
– and 25% from the EU

1 Willot Kingston Smith.
2 Construction Industry Council (CIC) and the Department of the Environment, Transport and the Regions (DETR), *Survey of UK Construction Professional Services*, 1997.
3 CIC/DETR, *Survey of UK Construction Professional Services*, 1997.
4 CIC/DETR, *Survey of UK Construction Professional Services*, 1997.

Employment[5]
- In 1997, there were 30,700 architects registered in the UK
- of whom 24,100 were employed in the UK workforce
- 11% of whom were women

Forecast growth
- Assuming a CAGR of 5%, architecture revenues will reach £2.6bn in 2007

Art and Antiques

London is the only truly international centre for the art market in Europe, and is second in the world only to New York. The UK art market supports some 10,000 businesses. It also contributes to the UK economy indirectly: expenditure by foreign visitors who regarded the art market as either a 'very important' or 'quite important' reason for their visit to Britain amounted to over £2.8bn in 1995.[6]

UK consumer market[7]
in 1996
- Total turnover in art and antiques: £2.2bn
- and support services generated an additional £251m

Employment[8]
- Total art and antiques sector employment in 1996 was 40,000

Forecast growth
- Assuming a 5% CAGR, the art and antiques market will be worth £3.8bn by 2007

Computer Games

The UK computer-games industry is ranked amongst the very best in the world, and the global market is growing rapidly. However, most British-developed games are published and distributed by foreign companies. Sales of British games in overseas markets could bring in hundreds of millions of pounds to the UK.

5 The Royal Institute of British Architects (RIBA).
6 Market Tracking International, for the British Art Market Federation (BAMF).
7 Market Tracking International, for BAMF.
8 Market Tracking International, for BAMF.

UK consumer market
in 1989
- The UK combined games console/computer and video software market was worth £200m in 1989[9]

in 1997
- £605m software + £284m console hardware
- = total market £890m[10]

UK industry revenues
- No comprehensive revenue data available, and no data reporting import/export revenues
- but Eidos, the UK market leader, had revenues of £376m in the year ending April 1997

Investment (including inward investment)
- As games can take up to three years and millions of pounds to develop, the risk of investment is high; as a result British companies often look overseas for investment, and many have been acquired by American rivals

Employment
- Between 60,000 and 80,000

Performance indicators
- Britain is renowned for its innovation and the quality of its games, with British-developed software titles accounting for about 35–40% of world sales – but about half of these titles are published by foreign companies.

Forecast growth
- Assuming a CAGR of 7%, the computer-games market in the UK will be worth £1.8bn in 2007
- The size of the UK computer-games industry could be much greater if Britain captured a larger share of the world market

9 ChartTrack.
10 ChartTrack.

Crafts

The UK contemporary crafts industry has more than doubled its turnover in the last ten years, making crafts a significant sector of the small-business economy. Much of the craft industries' contribution to the economy is hidden within the figures for tourism (both domestic and international). In general, there is a real shortage of current and historical data for the industry.

UK consumer market
– No data exists related to the size of the UK market – which is estimated to be over £400m

UK industry revenues = *UK only*
– About £400m **turnover** (i.e. does not take into account overseas transactions) for contemporary crafts industry as a whole[11]
– With no import/export figures it is impossible to generate a more accurate figure for overall industry revenues

Balance of Trade
	Exports	Imports	Balance of Trade
1990	n/a	n/a	n/a
1997	c. £20m[12]	n/a	n/a

Employment[13]
– About 25,000
– Over 96% of businesses are one- or two-person operations
– 57% of craftspeople are women, but men earn, on average, £20,000 more per annum

Performance indicators
– There are approximately 4,000 craft fairs held in the UK every year, with an estimated turnover of £16m

Forecast growth
– Sales of crafts at home and overseas have increased by *c.* 5% year on year and we can expect the same rate of growth to continue
– resulting in a £700m value for the sector in 2007

|

11, 12, 13 The Crafts Council.

Design

The design industry includes design consultancy and the design element within manufacturing – representing 2.6% of manufacturing turnover.

'Design-intensive firms and industries are faster-growing, more profitable, and more successful in export markets.'

Design Council

UK consumer market
- The consumer market for design is made up of two parts: clients of design consultancies, and companies spending internally on design
- The most recent indication of market size is the Design Council's estimate of £12bn spent on design services in 1995

UK industry revenues = *UK only* [14]
mid-80s
- Design consultancies had a combined turnover of £1.1bn
- This is a small fraction of the amount spent on industrial design, for which we do not have any historical data

1995
- £10bn spent by British manufacturing industry on product development and design
- £3.1bn spent on design consultancies
- Assume overlap of £1bn
- = £12bn

Exports[15]
mid-80s
- £175m for design consultancies only

1995
- £350m for design consultancies only

Employment[16]
- 173,000 in manufacturing industry
- 41,000 in design consultancies
- Total = 300,000

Forecast growth
- Given 5% growth, the UK design industry will generate £21bn in revenues in 2007

14, 15, 16 The Design Council.

Designer Fashion

The UK fashion industry has an importance and prominence out of proportion to its size. London is seen as one of the key global hubs for the fashion business – best illustrated by the rise of London Fashion Week, which has tripled in size in the last four years. However, there is very limited statistical information available for the sector.

UK consumer market
- Sales of clothing and textiles total £22bn
- There is no indication of what proportion of this total is spent on designer fashion

UK industry revenues = *UK revenue + overseas revenue* [17]
1990
– £185m

1997
– £600m

Balance of Trade
- There is no historical data and no import data, so it is not possible to determine net receipts
- UK designers' share of the total UK designer fashion retail market is probably low, because of the proliferation of US and continental boutiques

	Exports	Imports	Balance of Trade
1990	n/a	n/a	n/a
1997	c. £260m[18]	n/a	n/a

Employment[19]
- Direct employment c. 1,000–1,500
- Total employment in apparel manufacturing industry is about 220,000

Forecast growth
- Given 5% growth, the UK fashion industry will generate £1bn in revenues in 2007

17 Department of Trade and Industry (DTI).
18 DTI.
19 DTI.

Film

'*The UK is undoubtedly a more congenial place to make films these days. Those Lottery awards, more generous tax breaks and a multitude of regional incentives mean there is plenty of action beyond the traditional movie square mile of London Soho.*'

Moving Pictures, January 1998

UK consumer market
1997
- £2bn spent on films in the UK (including cinema box office, pay-TV, video rental and retail)

UK industry revenues
1997
- UK consumer spend on UK films: £160m + estimated overseas receipts: £545m + inward investment: £217m
- Total UK industry revenues = £922m

Balance of Trade[20]
- The positive net receipt figure is misleading, in that it does not reflect the flow of UK-made films' invisible revenues out of the UK economy

	Exports	*Imports*	*Balance of Trade*
1990	£334m	£266m	+ £68m
1996	£522m	£431m	+ £91m

Investment
1997
- Production spend on UK films £558m
- Inward investment £217m

Employment[21]
- Direct employment 33,000
- 21% of whom are actors, producers and directors
- 42% of whom are women

20 Office of National Statistics (ONS).
21 Arts Council of England (ACE), *Employment in the Arts and Cultural Industries: An Analysis of the 1991 Census.*

Projected size and scale of the sector
- Spectrum estimates that by 2007, the total UK consumer spend on films will exceed £3bn, with over £400m spent on UK films
- and the UK film industry will generate £800m in overseas receipts

Music

The UK music industry is very strong both at home and overseas, and second only to the US in terms of exports – exports more than trebled (to £1.5bn) between 1985 and 1993, and could reach £3bn by 2007. Music sales in the UK have been growing at a 10% Compound Annual Growth Rate for ten years.

UK consumer market[22]
1996
- Consumer expenditure £2.4bn + private corporate expenditure £168m + public-sector expenditure £198m
- = £2.6bn

UK industry revenues = *UK revenues + exports - imports* [23]
1996
- £3.4bn

Balance of Trade[24]
- There is no historical data available for invisible exports and imports, excepting a 1995 study (*Overseas Earnings of the Music Industry*) which gives a figure for net receipts in 1993

	Exports	Imports	Balance of Trade
1990	£184m finished goods	£109m finished goods	
			£571m in 1993[25]
1996	£359m finished goods (estimated total £1.5bn visibles and invisibles[26])	£278m finished goods	£81m finished goods

22 National Music Council.
23 Spectrum estimate for net receipts.
24 ONS.
25 *Overseas Earnings of the Music Industry*, 1995.
26 Spectrum estimate.

Investment
- Record companies invest approximately 12–13% of revenues in artists and repertoire

Employment
- In 1995, there were 90,600 employed in the music industry (excluding the musical instruments and education and training sectors)[27]
- The BPI estimates that at least 160,000 people are involved in the creation and distribution of music

Performance indicators
- The UK is the 4th largest market in the world
- The British Phonographic Institute estimates that UK artists' share of the world music market was 18% in 1993
- The most recent 'UK Record Industry Annual Survey' estimates that the UK's share in 1996 was 16%

Forecast growth CAGR 1997–2007
- UK consumer spend 4%
- Exports 8%

Projected size and scale of the sector
- In 2007: £6.7bn
- Full-time equivalent employment: 159,000

Performing Arts

'*Internationally, Britain has a great presence in the performing-arts sector but nationally, it has issues. The industry needs national data and national marketing.*'

David Emerson, Theatre Management Association

UK industry revenues = *UK only* [28]
1996
- Consumer spend at the box office £291m
- Lottery money £200m

27 National Music Council.
28 Independent Theatre Commission (ITC), Society of London Theatres (SOLT), Theatre Management Association (TMA), National Lottery Report 96/97, ACE, ABSA, Spectrum Analysis.

- Arts Council and Regional Arts Board grants £126m
- Business sponsorship £29m
- Other public funding £150m
- Donations £32m
- Total = £828m

Balance of Trade
- There is very little data available on the UK trade balance from the performing-arts sector, apart from anecdotal evidence
- Large commercial houses such as Cameron Mackintosh and the Really Useful Company are very successful at touring British musicals around the world
- The national flagship companies tour extensively overseas and generate significant earnings

Employment
- In 1994, at least 60,000 people reported that their 'main job' was in the performing-arts sector
- of whom 32,000 were performers

Forecast growth
- Assuming a 5% CAGR in the private sector, and 2.5% CAGR (i.e. exactly in line with inflation) in the public sector, performing arts industry revenues will reach £1.2bn in 2007

Publishing

Publishing is the largest of the creative industries in the UK, and it has a considerable impact on UK exports and employment. Electronic publishing is the area of rapid growth, but there is a distinct lack of economic data relating to this sector.

UK consumer market
1996
- Magazine sector £3.7bn[29]
- Books sector £2.7bn[30]
- Newspaper sector £6.2bn[31]

29 *Advertising Statistics Yearbook* 1997.
30 *Publishers' Association Book Trade Yearbook* 1997.
31 *Advertising Statistics Yearbook* 1997.

- Electronic publishing sector £3–4bn[32]
- Total £15.6bn

UK industry revenues = *UK revenues + exports – imports* [33]
1990
- £11.5bn

1996
- £17.5bn

Balance of Trade[34]
- Statistical data is available only for visible imports and exports, although there is a sizeable trade in invisibles – rights and royalties

	Exports	*Imports*	*Balance of Trade*
1992	visibles: £1,049m	visibles: £727m	visibles: £322m
1996	visibles: £1.7bn	visibles: £840m	visibles: £892m
	Net royalty income £500m[35]		

Employment
- 125,000 direct employment[36]

Forecast growth CAGR 1997–2007
- Total publishing industry 4%
- Print 3%
- Electronic 7%

Projected size and scale of the sector
- In 2007: £27.3bn both print and electronic

32 Spectrum estimate.
33 *Publishers' Association Book Trade Yearbook* 1997; *Advertising Statistics Yearbook* 1997; Spectrum estimates.
34 ONS.
35 Clive Bradley, Director, Confederation of Information Communication Industries.
36 ONS, *Labour Market Trends*.

Software

The software industry is both large and dynamic but its evolutionary nature poses difficulties for definition and measurement. Core activities of the industry include system software, contract/bespoke, fixed price development, systems integration, software products – tools and applications, turnkey solutions. Software services form a part of the overarching computer software and computing services market. Smaller software companies are suffering from integration and free product sales by the largest players.

UK consumer market[37]

1994
- £9.8bn market for computer software and computing services, of which £6.3bn software

1996
- £12.7bn market for computer software and computing services, of which £7.8bn software

Investment
- US companies are investing in small UK companies and setting up production and research plants in the UK

Employment
- Estimated figures put the number of businesses in this sector at 50,000 with 240,000 employees
- High proportion of contract staff reflects shift to outsourcing

Performance indicators
- The UK is recognized as a producer of highly innovative and creative individuals in this field
- 40% of games software is authored in the UK but published elsewhere

Forecast growth
- 1996/97 growth rate for computing and software services estimated at 12.6%
- Projected CAGR 1997-2000 is 11% for total software and computing services
- For software alone, CAGR is projected at 9.9%

37 Holway Report, 1997.

Projected size and scale of the sector
- Reliable forecasts suggest that software services will have a total revenue of £11.5bn in 2000, accounting for 59% of the total software and computing-services market
- Projecting forward at a CAGR of 9%, the software market will grow to £21bn by 2007

Television and Radio

The UK television industry continues to gain critical international acclaim. Despite the fact that exports have doubled in the last ten years, there is a growing trade deficit as more and more imports are drawn in by the multi-channel packages. Digital television and radio will create more competition and offer viewers new on-demand and online services.

'*Digital technology will allow choice and encourage competition on an unprecedented scale.*'

John Birt, BBC chief executive

UK consumer market
1990
- Licence fee £1.2bn[38] + pay-TV (excluding equipment) £167m[39] + ad spend £1.8bn[40]
- = £3.2bn
- Radio ad revenues £163m[41]

1996
- Licence fee £1.8bn[42] + pay-TV (excluding equipment) £1.4bn[43] + ad spend £2.5bn[44]
- = £5.7bn
- Radio ad revenues £309m

38 *Kagan's European Television Channels,* 1996.
39 Zenith Media, *TV in Europe to 2006.*
40 Zenith Media, *TV in Europe to 2006.*
41 Media Pocket Book 1996.
42 BBC Annual Report & Spectrum analysis.
43 Zenith Media, *TV in Europe to 2006.*
44 Zenith Media, *TV in Europe to 2006.*

UK industry revenues = *UK revenues + exports - imports*
1990
– £3.2bn

1996
– £5.7bn – £0.3bn trade deficit = £5.4bn
– + radio ad revenues £0.3bn
– = £5.7bn

Balance of Trade[45]

	Exports	Imports	Balance of Trade
1990	£128m	£207m	– £79m
1996	£234m	£516m	– £282m

Investment[46]
– £1.9bn investment in original programming in 1996

Employment
– 60,000 in 1996[47]
– Women account for 40% of actors and producers and 18% of technicians[48]
– The radio industry employs 3,800 people, 58% of whom work for the BBC[49]

Performance indicators
– UK television won thirteen international awards in 1996

Projected size and scale of the sector
– At 6% CAGR, in 2007: licence fees £2.6bn + ad spend £4.7bn + pay-TV £3.5bn
– and radio £528m

45 British Council, ONS Press Release 10/10/97.
46 Annual Reports & Spectrum analysis.
47 Annual Reports, PACT and Spectrum analysis.
48 ACE, *Employment in the Arts and Cultural Industries and Analysis of the Labour Force Survey and Other Sources*, 1997.
49 Skillset, *Radio Survey*.

Index